THEN & NOW

DOWNTOWN SILVER SPRING

OPPOSITE: The detail of a photograph taken by William H. Reynolds in August 1948 is looking north on Georgia Avenue from the nearly completed Baltimore and Ohio Railroad underpass. A work crew spreads topsoil on one of the new traffic islands. See page 17 for a view of the south side of the underpass. (Joseph C. Reynolds.)

THEN & NOW

DOWNTOWN SILVER SPRING

Jerry A. McCoy and the
Silver Spring Historical Society
Foreword by George Pelecanos

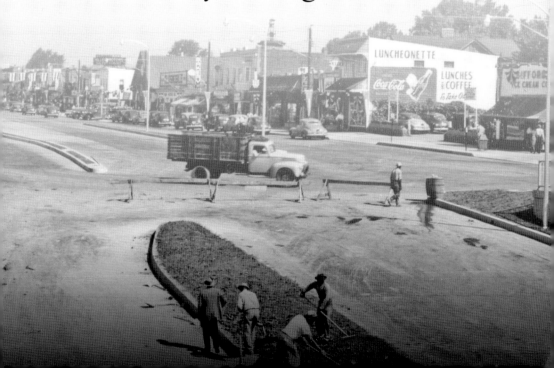

This book is dedicated to the Lorain City Public Schools (Ohio), which taught me in 1970 the importance of documenting local history through the pages of its seventh-grade curriculum book, The Story of Lorain: Our International City.

Copyright © 2010 by Jerry A. McCoy and the Silver Spring Historical Society
ISBN 978-0-7385-8631-1

Library of Congress Control Number: 2010923962

Published by Arcadia Publishing
Charleston, South Carolina

Printed in the United States of America

Then and Now is a registered trademark and is used under license from Salamander Books Limited

For all general information, please contact Arcadia Publishing:
Telephone 843-853-2070
Fax 843-853-0044
E-mail sales@arcadiapublishing.com
For customer service and orders:
Toll-Free 1-888-313-2665

Visit us on the Internet at www.arcadiapublishing.com

ON THE FRONT COVER: This 1927 National Photo Company photograph shows a residence at 8424 Georgia Avenue occupying the corner lot at left. Across Wayne Avenue (then Harden Street) is the Knights of Columbus Hall, dedicated April 10, 1927 (see page 36). The banner on the portico reads, "Chicken Dinner Here Saturday Next 5 to 8 PM." Next to the hall is the Albert Buehler Provision Company. (Then image: John P. "Jack" Hewitt; Now image: Jerry A. McCoy .)

ON THE BACK COVER: The Hecht Company department store's opening at Fenton Street and Ellsworth Drive in 1947 had a profound positive economic impact on the postwar development of downtown Silver Spring. The convenient county-owned free parking lot, seen in this 1950 *Evening Star* photograph by John Horan, is the site of the Silver Spring Civic Building and Veterans Plaza, completed 2010. (Star Collection, D.C. Public Library, © the *Washington Post*.)

CONTENTS

FOREWORD

Today I came across an essay, "A Life of Friendship," written by Dr. John Nasou, a longtime Silver Spring resident and physician who had his practice on Pershing Drive for many years. The piece is a tribute to his lifelong friend, Francis Neil Waldrop, who recently passed. It is also a poetic look back at a downtown Silver Spring that most of us do not remember.

Dr. Nasou grew up here during the Depression, where he often wandered along Sligo Creek Park "studying the life forms of its then unpolluted waters." He recalls the many farms on Georgia Avenue, and the village smithy who worked in his shop, and the police station where he and Neil "walked unopposed" and greeted many of the town drunks in lockup, who they knew by name. Also known to them by name were the ladies who worked in "the place with the red light," prewar Silver Spring's house of ill repute. The local numbers game was conducted in a store that operated like a small bank.

John Nasou lived with his family in an apartment above his father's restaurant, the Senate Lunch, where the Discovery Building now stands. Neil Waldrop, whose father owned a Dixie Pig Barbecue, lived across Georgia Avenue, near the Acme Market.

Their story sounds lyrical, filtered, perhaps, by the gauze of selective memory and time. No doubt their lives were more innocent, relatively speaking, than those of succeeding generations.

I tend to remember the good and the rough. As a boy, I patronized the Hecht Company, Hahn's, the Reindeer Frozen Custard, Giffords, and the two-story H. L. Green Company with the wood floors, where kids bought their pets. I played a trumpet rented from Dale Music. My father almost purchased an American at the Rambler dealership across from the Reindeer (thankfully, he opted for a 1964 ½ Mustang instead), and my oldest sister bought her first car, a 1970 Camaro, at Loving Chevrolet on East-West Highway. I obtained a set of chrome reverse mags for that same car from Ken Lubel at Tires of Silver Spring five years later. That shop was opened by his father, Leon, in 1950. Like Hanagan's Auto Body on Selim, it is still a family-run business.

For a movie freak like me, the center of town was the Silver Theatre, a second-run KB house with an auditorium that seated 1,100. It was there that I saw all the Bond films, Leone's spaghetti westerns, *The Exorcist*, ultraviolent double features like *The Wild Bunch* paired with *Dirty Harry*, any number of chop socky flicks, B-classics like *Walking Tall* and *Billy Jack*, and *Scanners*, the Cronenberg picture where the dude's head goes ka-boom.

Downtown Silver Spring in the 1970s was a mix of longhairs and the last of the greasers, who could be seen in black leather behind the Drug Fair hot-boxing their Marlboro Reds. The latest stacks (shoes with big heels and lifters under the toes) were available at Daily Planet, and baggies (pleated, oversized pants) could be found at Solar Plexus, both on Ellsworth Drive, our alternative street. A young man could get a haircut and score something for his head on that same street. Ellsworth was razed and is now a row of chain retailers and chain restaurants, loaded with security and police, as well as music and nightlife. The National Guard Armory, former home of Milt Grant's famed Record Hops, was torn down and replaced by a parking garage. The Little Tavern, with their belly-bombs and eclectic juke box, is long gone. The Tastee Diner, where you could sober up with breakfast and coffee late at night, was picked up and moved

to a side street. Captain White's Seafood had raucous rock and blues bands playing in the back of the house. I bought Norman Lane, "the mayor," a drink there one night. There was even an unbeautiful gay bar on Georgia Avenue, down between Bonifant Street and Wayne Avenue. That place was never going to survive in this brave new world.

I am not against progress. I like the new downtown. The Silver is now the AFI, one of the best movie theaters in the country. A resident can walk to any number of good restaurants, bars, coffee shops, bookstores, and the Metro. There are auto mechanics, cobblers, and locksmiths here, people who actually work with their hands. Yeah, too many new buildings have gone up in the last decade, but those structures house businesses that employ my neighbors and their kids. This city has never been so vibrant or interesting in terms of its human makeup. There is no place like it in the area.

History is on a continuum, and the different phases of Silver Spring led to the one we are enjoying now. It is important that there are books like this one, a pictorial record of our home town, to go with the memories that flicker in our heads. Don't call it nostalgia. It is an appreciation for the past, with anticipation for what comes next.

—George Pelecanos
Silver Spring, Maryland
April 2010

ACKNOWLEDGMENTS

Thanks to the following people and organizations who have contributed to this book:

APS	Anne P. Solotar
BWF	Beverly Wright Fincham
CFM	Charles F. Marston
CTS	Charles T. Schrider Jr.
DD	Dan Dickson
DS	Dave Stovall
EBL	E. Brooke Lee III
GCD	Glen C. Dorsey
GEC	Grace Episcopal Church
GJ	Guy Jones
GL	Gary Levy
GS	Geof Schomings
HSWDC	Historical Society of Washington, D.C.
JAM	Jerry A. McCoy
JCR	Joseph C. Reynolds
JRH	John R. Hiltz
KL	Ken Lubel
LC-HAER	Library of Congress, Historic American Engineering Record (HAER MD-131-21)
LC-NPC	Library of Congress, Prints and Photographs Division, National Photo Company Collection (LC-F81-1207)
LC-NPC2	Library of Congress, Prints and Photographs Division, National Photo Company Collection (LC-F82-2393)
LC-THC	Library of Congress, Prints and Photographs Division, Theodor Horydczak Collection (LC-H814-1504-002)
MCHPC	Montgomery County Historic Preservation Commission
RBP	Ronald B. Pease
RKH	Robert K. Headley
RKN	Richard K. Neumann
SP	Sandra Pearlman
SSHS	Silver Spring Historical Society
STAR	Star Collection, DC Public Library, © the *Washington Post*
WASH	Washingtoniana Division, D.C. Public Library
WP	Wesley Ponder

Unless otherwise noted, all "now" images are courtesy of the author.

INTRODUCTION

Downtown Silver Spring's "revitalization" began nearly a generation ago, in 1987. The first failed proposal, dubbed the "Silver Triangle," called for a large-scale commercial center to be constructed at the intersection of Georgia Avenue and Colesville Road, Silver Spring's original "Main Streets." That project called for demolition of the streamline moderne 1938 Silver Theatre and Silver Spring Shopping Center. Seven years later, the developer responsible for building in Minnesota the world's largest (78-acre) covered shopping center, the Mall of America, proposed a 28-acre version for Silver Spring dubbed the American Dream. Thankfully, it too failed.

In 1997, the Montgomery County government established the Silver Spring Redevelopment Steering Committee, a group of civic, business, and community leaders tasked with creating a smaller-scaled revitalization project for the defined "core" of Silver Spring's Central Business District (CBD). This vision is coming to fruition. For a number of civic activists, a huge part of this vision was and remains the inclusion of historic preservation as an integral facet of our community's continued redevelopment. The goal to integrate important landmarks of Silver Spring's past, the structures that give our community character and a "sense of place," has been partly successful.

On one hand, the historic Silver Theatre and Silver Spring Shopping Center were saved and restored after a long and difficult preservation battle to become the centerpiece of the revitalized downtown Silver Spring. On the other hand, our Gothic Revival 1927 Maryland National Guard Armory, a designated county historic landmark, was sacrificed in 1998 to make room for a parking garage. This was despite the fact that there were a number of other parking facilities in the core and the area has convenient access to public transportation.

With redevelopment completed in the core—the area roughly bordered by Georgia Avenue, Colesville Road, Fenton Street, and Wayne Avenue—many civic activists hope that future redevelopment will not come at the expense of losing Silver Spring's oldest commercial buildings. Located further south on Georgia Avenue, and on Colesville Road, is an impressive assemblage of early- to mid-20th-century structures. Most of these are enlivened by multicultural small independent businesses offering residents and visitors a unique opportunity to connect with our origins and vibrant past.

This authenticity provides a unique opportunity for the creation of heritage tourism, a vital form of economic and educational development. These buildings are survivors of a true "Main Street" community, a rare commodity in Montgomery County and increasingly in large communities throughout the United States. Their human scale and walkable spaces exemplify an authentic environment that "new urbanist" planners around the country are striving to manufacture. Silver Spring already has the real thing, and these structures must be included in any future revitalization.

A promising step in that direction was the April 2010 unveiling of the first 6 of 20 planned markers on the Silver Spring Heritage Trail, created as legally required mitigation for the demolition of the armory. The Silver Spring Historical Society provided all of the text and photographs that appear on the signs, with fabrication funded by the county government. The SSHS anticipates that the trail will educate the public about the history our community and emphasize the importance of maintaining its sense of place.

English critic and art historian John Ruskin recognized as early as 1849 the importance of preserving our architectural heritage. In *The Seven Lamps of Architecture*, he wrote: "They [buildings of past times] are not ours. They belong partly to those who built them, and partly to all the generations of mankind who are to follow us. The dead have still their right in them: that which they labored for, the praise of achievement or the expression of religious feeling, or whatsoever else it might be which in those buildings they intended to be permanent, we have no right to obliterate."

The pairing of "Then" and "Now" images in *Downtown Silver Spring* illustrates that while many significant structures have been obliterated or are imminently endangered, many have survived. Photographs of buildings featured in this book, arranged in street address order, will allow the user to explore our community's rich history. With greater awareness of our past comes the fervent desire that these important buildings, and all they represent, will have an honored place in 21st-century downtown Silver Spring.

If you have photographs of downtown Silver Spring, please share them with the Silver Spring Historical Society. Our address is P.O. Box 1160, Silver Spring, Maryland, 20910. Our e-mail address is sshistory@yahoo.com. To learn more about historic Silver Spring, please visit us at www.sshistory.org.

CHAPTER 1

GEORGIA AVENUE

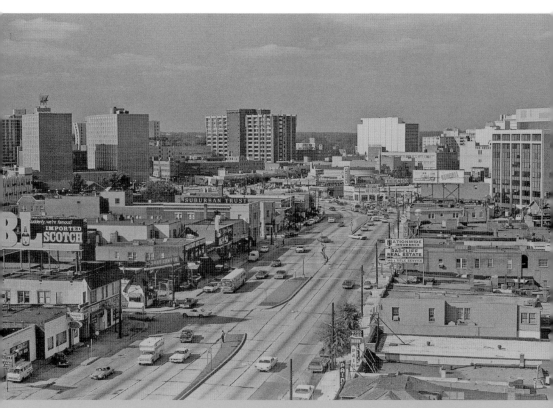

Georgia Avenue, one of downtown Silver Spring's two original main streets, began in 1849 as the Washington and Brookeville Turnpike or Seventh Street Pike. Despite being part of U.S. Route 29 with six lanes to accommodate traffic, the majority of the avenue's early-20th-century commercial and institutional structures are extant. This 1971 photograph is by Dave Stovall. (DS.)

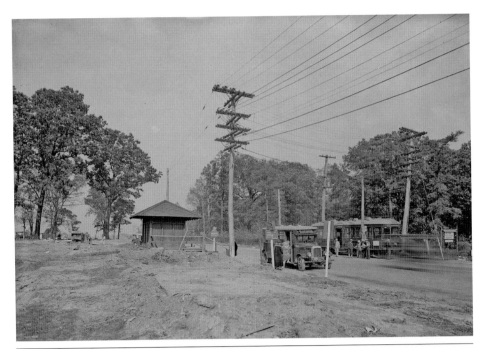

Washington, D.C., Capital Transit streetcar no. 624 sits at the end of the line on the northeast corner of Georgia Avenue and Blair Road in this 1927 photograph. Continuation of streetcar service into Maryland on the Washington, Woodside, and Forest Glen Railway ended in 1924 and was replaced by the Washington Rapid Transit Company. Operated by a consortium of developers, the company provided "direct transportation between suburban home building projects and downtown Washington." The bus destination sign reads "East Silver Spring." (LC-NPC2.)

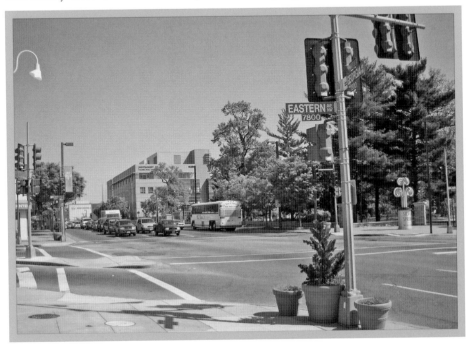

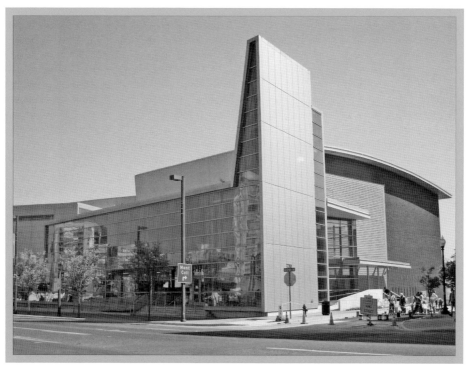

As early as 1939, a business named the Silver Spring Hotel operated at 7927 Georgia Avenue. By 1966, this earlier hotel had been replaced by a new 43-unit structure designed by Fred Luwis (pictured here on a postcard from that era). Developing a "No Tell Motel" reputation over the ensuing decades, the structure was razed in 2002 for eventual construction of Montgomery College's Takoma Park/Silver Spring Performing Arts Center, opened in 2009 with a concert by Aretha Franklin. (WP.)

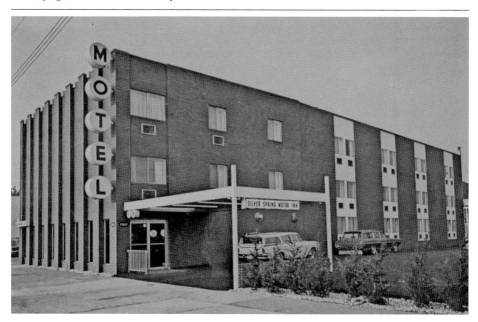

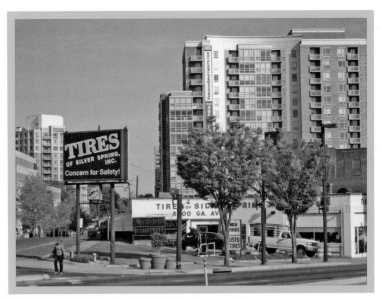

Originally built in 1934, 8000 Georgia Avenue was an automobile dealership selling Fords (Walsh Motor Company) and later Chryslers and Plymouths (Marcy Motors and Sid Wellborn). In 1952, Leon Lubel opened Silver Spring Tire Corporation, sharing the address for a short time with Blue Banner Laundry and Dry Cleaners. Silver Spring Tires has long occupied the entire structure and continues operating from the same location in 2010. (KL.)

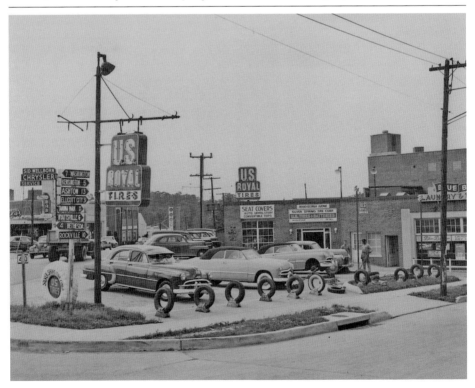

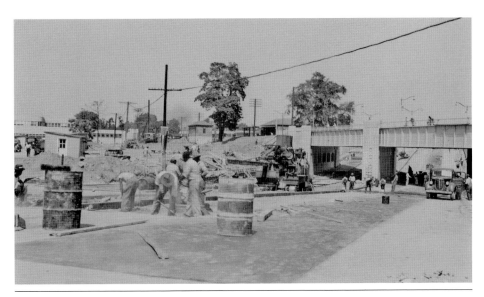

In August 1948, William H. Reynolds photographed a work crew preparing the roadbed for pouring concrete to complete the "Avenue of Progress." The repaved Georgia Avenue marked the opening of the new $1.4-million Baltimore and Ohio Railroad underpass ($12.6 million in 2010), whose south elevation is shown here. Totaling six lanes, Georgia Avenue extended from East-West Highway to Colesville Road. In 2004, the 20,000-square-foot Silver Spring Innovation Center (center) opened at 8070 Georgia Avenue. (JCR.)

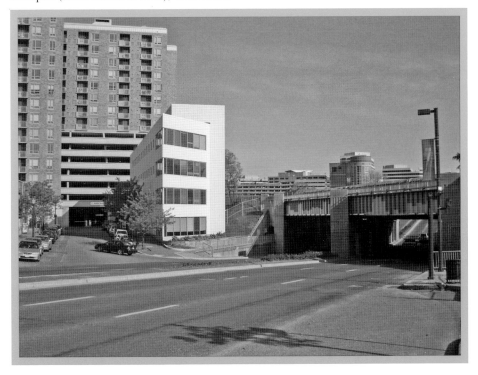

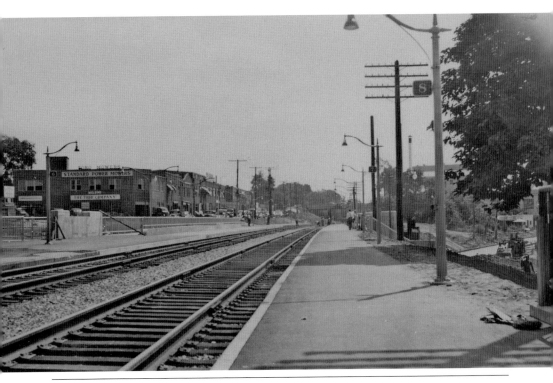

William H. Reynolds took this photograph in August 1948 from the Baltimore and Ohio (B&O) Railroad eastbound station. The buildings on the left front Selim Avenue (named after the horse Francis Preston Blair or his daughter Elizabeth was riding when the "silver" spring was discovered in 1840). Numbered signs attached to the light poles informed B&O passengers where to stand to embark on their train. The track bed was widened to accommodate the inclusion of Metrorail in 1978. (JCR.)

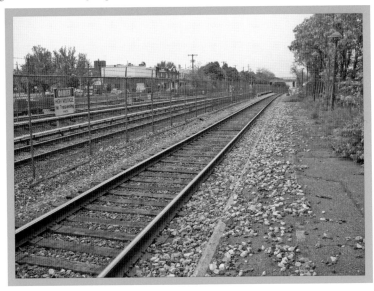

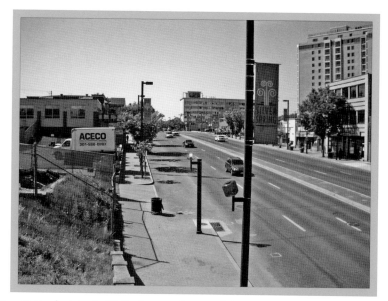

Washington, D.C., physician Ira W. Pearlman took this photograph in August 1948 looking south from the vicinity of the nearly completed Baltimore and Ohio Railroad underpass. It replaced an earlier underpass constructed in 1925 that was prone to flooding and accidents. Perpendicular and parallel parking was allowed on the northbound lane of Georgia Avenue because it ended at the construction site. A 60-float parade viewed by 70,000 people accompanied the underpass's dedication on September 11, 1948. (SP.)

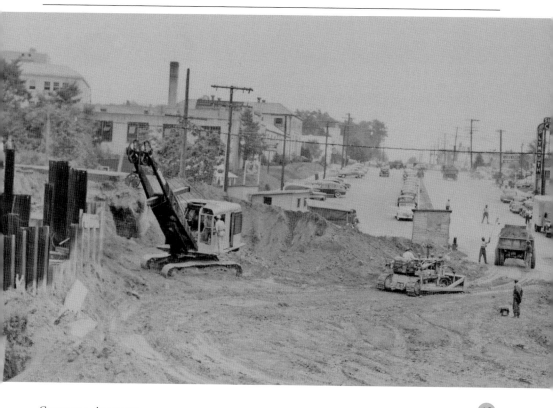

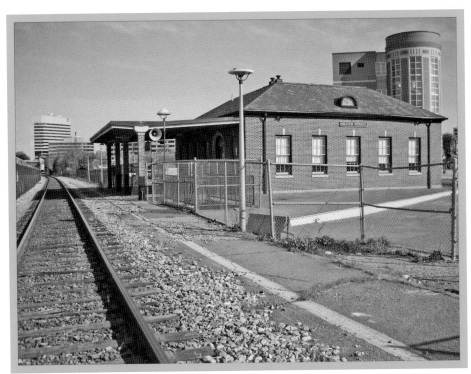

Silver Spring's Baltimore and Ohio Railroad station opened in 1878. Photographed by Willard R. Ross on June 21, 1917, the station was razed in August 1945. It was replaced with a modern $85,000 facility ($1.02 million in 2010) that opened on December 16, 1945. Restored in 2000 and listed on the National Register of Historic Places, the station at 8100 Georgia Avenue is owned by Montgomery Preservation, Inc., and available for rent. Contact MPI at (301) 495-4915 or visit www.montgomerypreservation.org. (SSHS.)

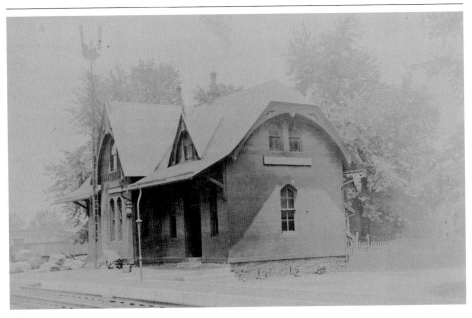

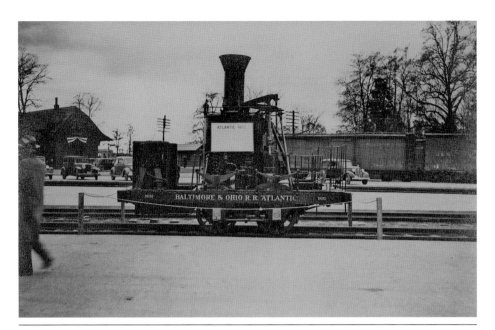

In celebration of Silver Spring becoming a stop for long-distance trains, the Baltimore and Ohio Railroad sponsored an exhibit of vintage railroad equipment on November 14–15, 1936, in the station's freight yard. One piece displayed was an 1836 locomotive altered in 1892 to look like the *Atlantic*, an early steam locomotive built for the B&O in 1832. Silver Spring's original 1878 station appears in the left background. The Silver Spring Fire Department and parking lot are here now. (SSHS.)

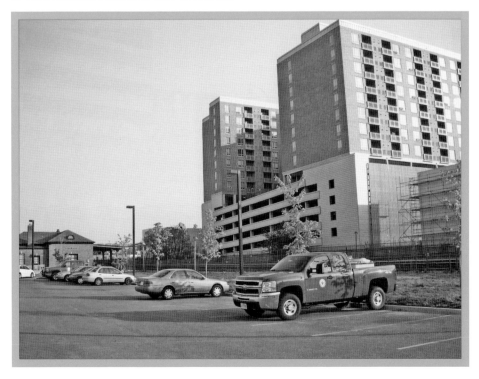

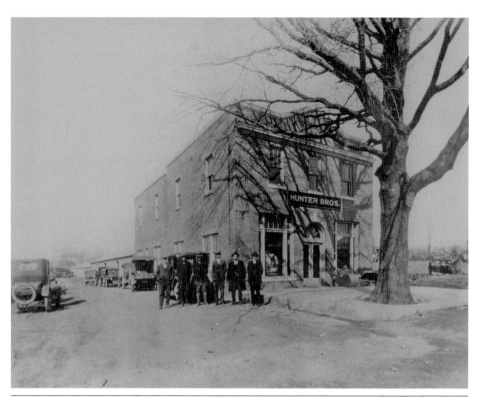

John and Thomas Hunter opened Hunter Brothers Hardware in 1914. In 1925, they replaced their wooden store with a two-story brick structure still standing at 8126 Georgia Avenue (not 1896, as misconstrued by the date on the building's cornerstone). In 1945, the business was sold to Lawrence B. Maloney Sr., and four years later, a modernistic front designed by world-renowned industrial designer Raymond Loewy was added as part of the store's International Harvester franchise. The business closed in 1984. (SSHS.)

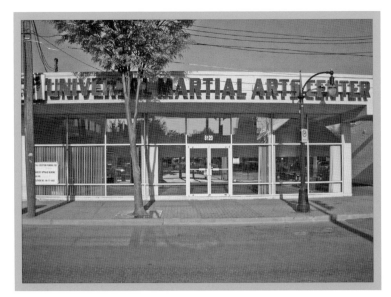

Posing around 1917 in front of Hunter Brothers Hardware, from left to right, are local children Mary L., Marion C., and John D. Schrider. The Schriders lived at 607 Sligo Avenue. The area where they stood became part of the enlarged Maloney's Hardware, whose new dealer showroom, designed by Raymond Loewy, was added in 1949. Loewy is best known for such American design icons as the Coca-Cola bottle, Air Force One, and the Exxon and Shell logos. (CTS.)

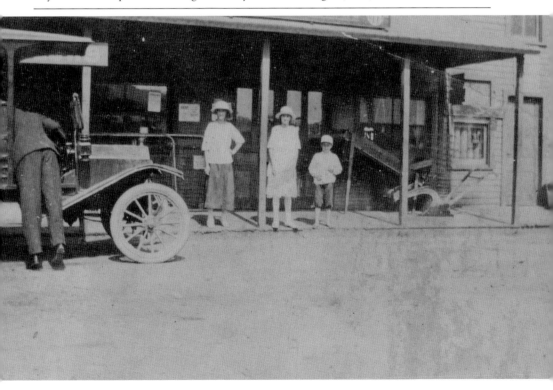

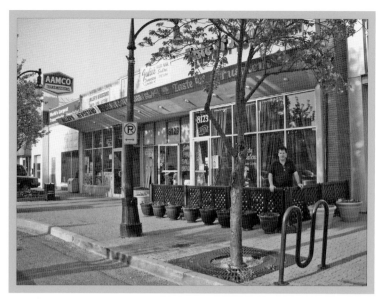

In 1918, druggist William F. Mattingly lived in Washington, D.C., and with his son operated two pharmacies, one at 1100 Fourteenth Street, NW, and the other at 8123 Georgia Avenue (then known as Brookeville Pike). The Silver Spring Post Office was located directly next door to the pharmacy. Three businesses still occupy this structure today, whose facade was modernized in 1957. Owner/chef Kamal Hawa poses in front of Taste of Jerusalem, located at 8123 Georgia Avenue. (GJ.)

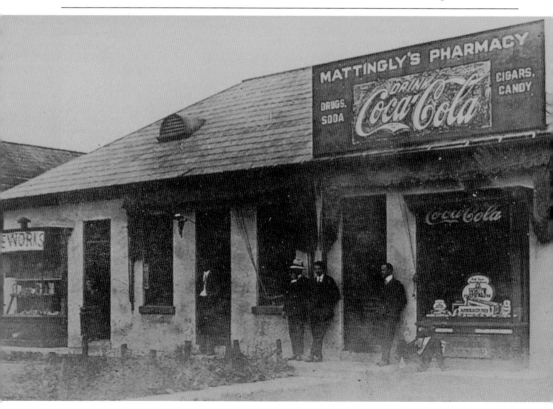

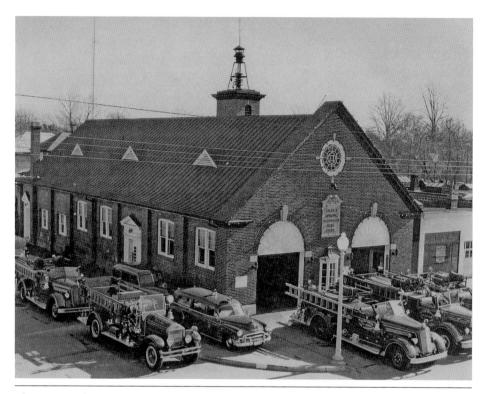

Silver Spring Volunteer Fire Department No. 1, at 8131 Georgia Avenue, was constructed in 1914 as the Silver Spring Armory. The department shared the space initially, becoming the sole occupant in 1927. Shown here in 1954, the station was replaced in 2006 with a facility at 8110 Georgia Avenue. The firehouse was remodeled in 2010 as Fire Station 1 Restaurant and Brewing Company. Maryland lieutenant governor Anthony G. Brown gives a speech on April 30, 2010, as part of his statewide "Main Street Recovery Tour." (GL.)

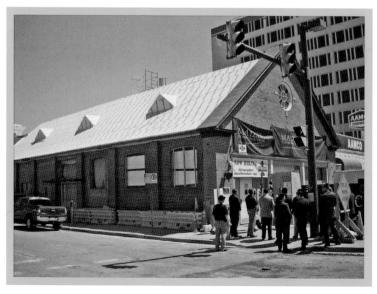

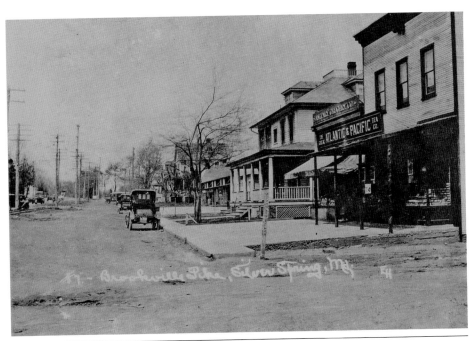

A simple wooden post stenciled "Silver Spring Ave./Brookville Pike" appears (center) on this 1915 postcard view of today's Georgia Avenue looking north. The photograph credit "EH" was most likely Egbert Holland, a 37-year-old post office clerk who lived with his wife, Laura, on the pike. The Great Atlantic and Pacific Tea Company at 8201 Georgia Avenue has been the home of Bell Flowers since 1947 and survives as the oldest commercial structure in downtown Silver Spring. (SSHS.)

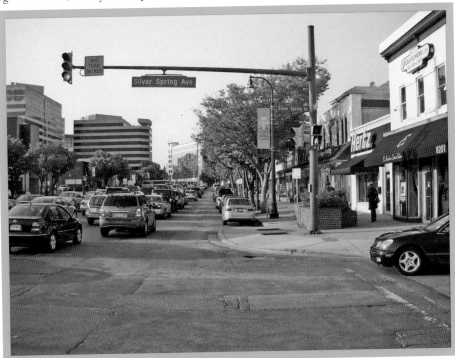

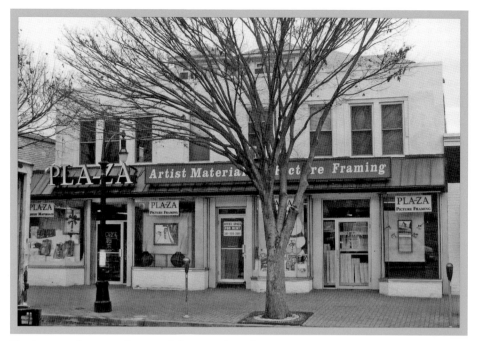

The American foursquare house with front porch visible on the previous page was the residence of Hugh F. O'Donnell, a contractor, from 1916 to 1918. Located at 8209 Georgia Avenue, this house and others on the street were slowly converted to commercial use. By 1927, when this photograph was taken, the structure was occupied by a drugstore operated by Howell Forsyth. Upper floors were rented out as apartments. The house's original hipped roof dormers are still visible. (EBL.)

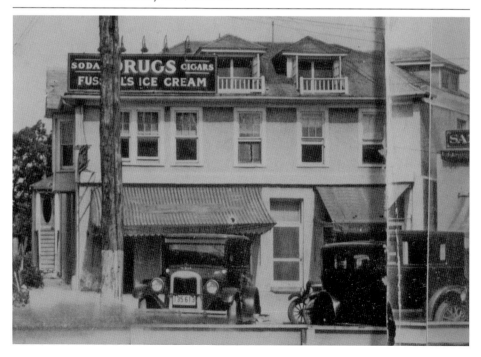

This unidentified young lady artfully poses in the early 1920s with a gravity-feed gasoline pump in front of Bill's Garage ("Watch Us Grow"). Bill's was located in the vicinity of today's 8211 Georgia Avenue, constructed in 1927. The caged 10-gallon glass cylinder dispensed "That Good Gulf Gasoline," permitting customers to see that the amount of gasoline paid for was the amount received. (CFM.)

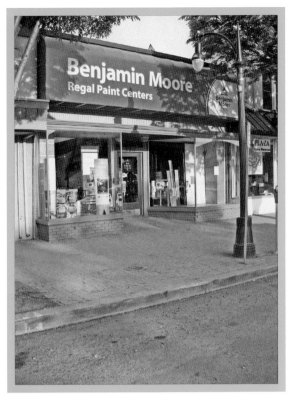

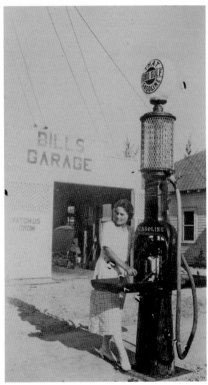

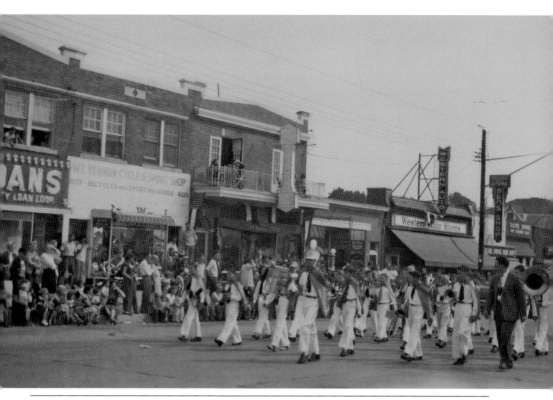

Jay Braun photographed this marching band participating in Silver Spring's "Avenue of Progress" parade on September 11, 1948. The three two-story buildings in the background (from left to right, 8225, 8223, and 8221 Georgia Avenue) were constructed in 1926. John J. Dolan constructed 8225 and 8223, and Moses Sclar constructed 8221 to house both his Grand Leader department store and his family, who lived upstairs. These are among the best-preserved examples of early-20th-century commercial architecture in Silver Spring. (JRH.)

Participants on Jerry A. McCoy's April 2007 walking tour of Georgia Avenue admire the intact 1922 Silver Spring Building Supply Company at 8222–8226 Georgia Avenue. Retaining its three-over-one, double-hung wooden sash windows and black slate canopy roof, the building's owner was quoted in the February 25, 2005, *Business Gazette* as saying that he would "restore it to its original splendor." The anticipated restoration became a renovation, robbing the structure of its unique character and history. The then photograph is by Marcie Stickle and the now is by George French. (SSHS.)

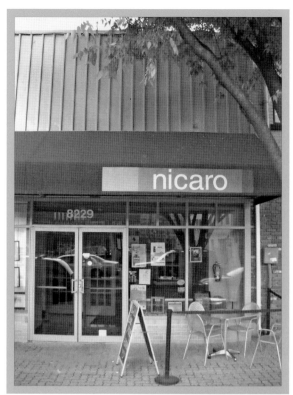

Watchmaker William M. Wright's second shop location during the 1940s was an attractive addition to Silver Spring's business streetscape. Located at 8229 Georgia Avenue, Wright had the building, constructed in 1933, refaced with black Vitrolite glass panels that served as background to his prominent neon sign. Vitrolite was a popular opaque glass available in various colors that was associated with the art deco movement. It was used in both new construction and renovations. None of this striking facade survives. (BWF.)

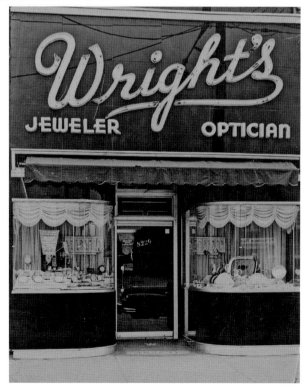

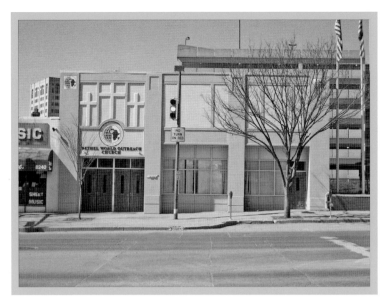

Silver Spring's first movie theater, the SECO, opened at 8242 Georgia Avenue in 1927. In 1953, new owner Sam Roth hired Silver Spring architect Warren G. Sargent to design this theater in its place. The Bing Crosby film *Man on Fire* played August 18–20, 1957. Ten years after the theater closed in 1991, owner Bethel World Outreach Church tore out the glass and turquoise terrazzo panels and buried the brick facade under Dryvit, Styrofoam panels covered with painted stucco. (GCD.)

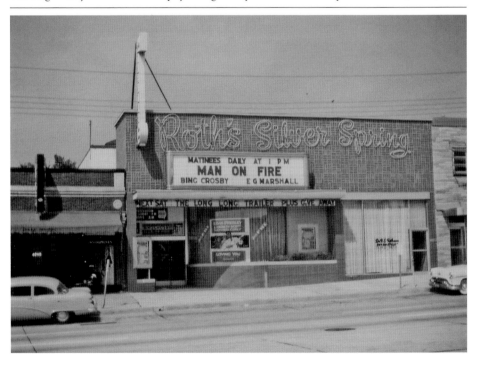

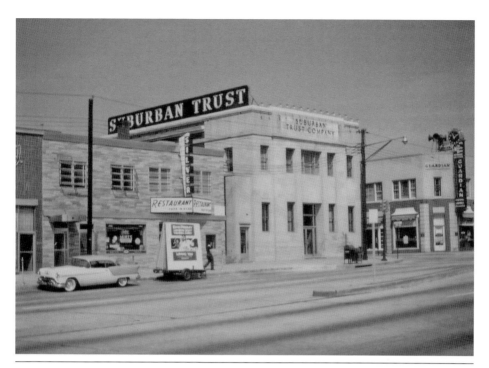

The sandwich board in front of the Silver Restaurant (destroyed by fire around 1972) advertised Elvis Presley's *Loving You*, which played at Roth's from August 23 to September 1, 1957. The Silver Spring National Bank at 8252 Georgia Avenue, constructed in 1925 with a 1938 addition, is also owned by Bethel World Outreach Church. The Guardian Building at 8400 Georgia Avenue was built in two stages—around 1933 with a second floor added in 1946. It was razed in the 1980s. (GCD.)

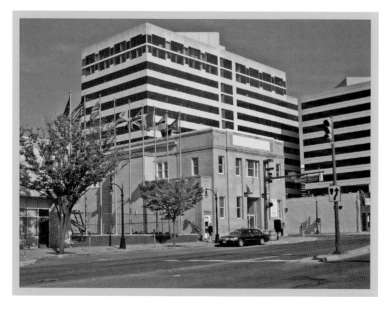

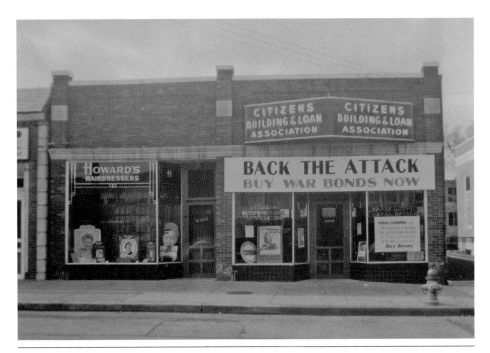

Constructed in 1937, 8406–8408 Georgia Avenue incorporated unusual multihued brickwork that has retained its coloration over seven decades. Nellie "Sis" Hewitt Stinchcomb took the photograph in 1943. "Back the Attack" referred to an exhibit held in September 1943 on the grounds of the Washington Monument in support of the U.S. war effort. Gutted by fire in 2001, the building was admirably renovated in 2009. The building is home to the landmark 1866 Washington, D.C., business Original Velatis Famous Caramels. (SSHS.)

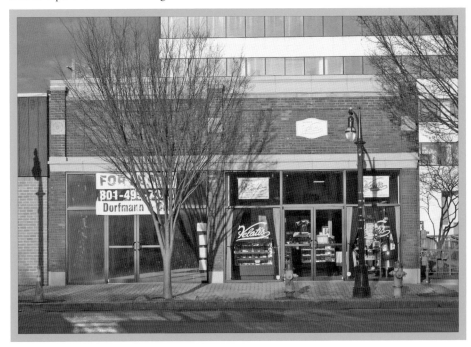

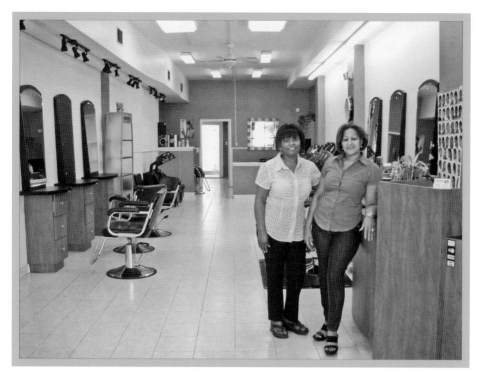

Wright's Jewelry Shop first opened at 8421 Georgia Avenue on November 18, 1936. Founder and owner William M. Wright stands behind the counter. The identity of his employees is unknown.

Since 2009, Sasha Unisex has occupied the same space (now 8419 Georgia Avenue). Manager Diomida Cristo (left) and owner Anna Marmolejon (right) pose in the shop. (BWF.)

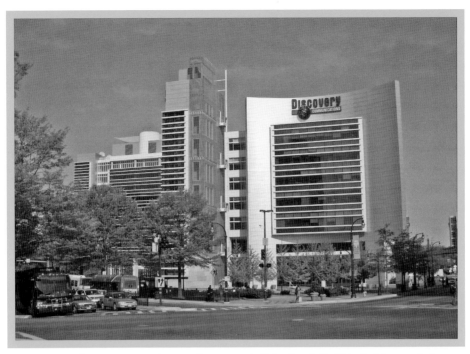

This portion of a panoramic photograph was taken April 10, 1927, by Washington, D.C., photographer William H. Waters. The gathering at the northwest corner of Georgia Avenue and Harden Street (today's Wayne Avenue) was for the cornerstone laying and dedication of the Knights of Columbus hall. This building and the one behind it were razed in 1974 when Wayne Avenue was widened to accommodate traffic that would access the Silver Spring Metro Station, opened in 1978. (SSHS.)

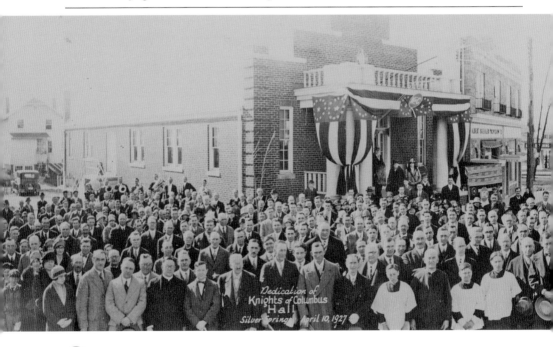

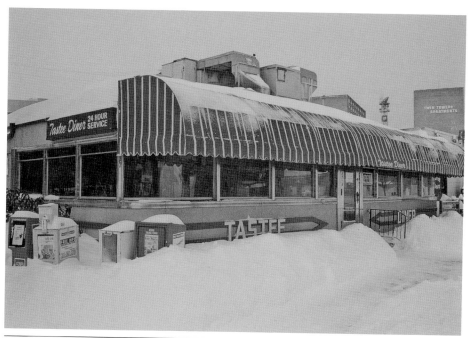

From 1946 to 2000, Tastee Diner's 24-hour service could be found at 8516 Georgia Avenue. This classic art deco/streamline moderne diner, constructed by Jerry O'Mahoney, Inc., of Elizabeth, New Jersey, was relocated to 8601 Cameron Street due to construction of the world headquarters of Discovery Communications, Inc. (opened in 2003). Tastee's survival was featured in the nationally syndicated "Zippy the Pinhead" comic strip on October 2, 2000. Photographed on January 9, 1996, Tastee's footprint is now occupied by Discovery Plaza. (JAM.)

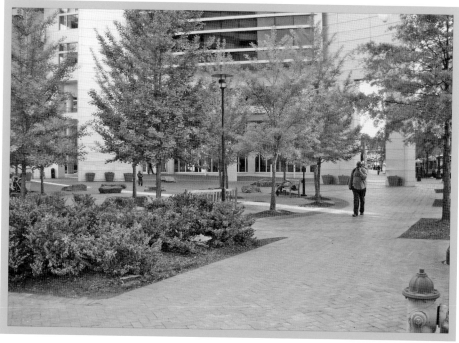

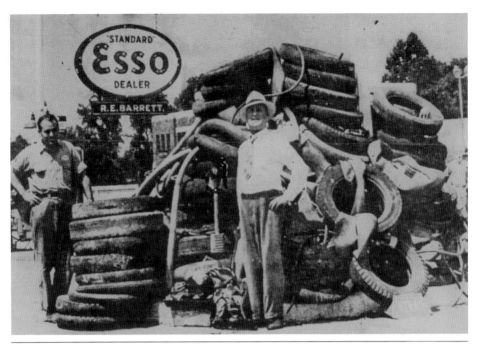

William Winn's photograph appeared in the July 9, 1942, *Silver Spring Standard-Montgomery Independent*. The caption read, "Ray E. Barrett, proprietor of the service station bearing his name, and John Wrathall, manager, standing in front of one of the huge piles of rubber accumulated at the station." Rubber was collected by the public to help in the U.S. war effort. The site of the scrap pile today is the sidewalk that runs along the Colesville Road side of Discovery Communications. (SSHS.)

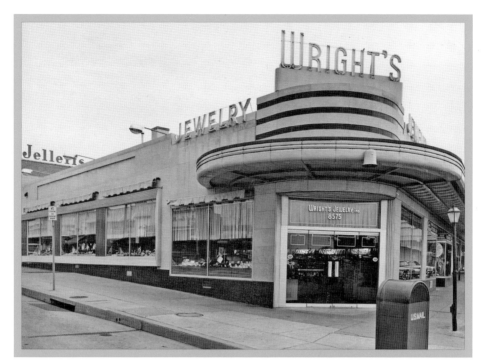

"Wright on the Corner" aptly described William M. Wright's third jewelry store, located at 8575 Georgia Avenue, where it intersects with Colesville Road. Opened 1954 in the John Eberson–designed 1938 Silver Spring Shopping Center, the business carried an expanded selection of diamonds, jewelry, watches, and silverware. Today hungry customers visit this same space to patronize Panera Bread, opened in 2003 with the address of 8541 Georgia Avenue. (BWF.)

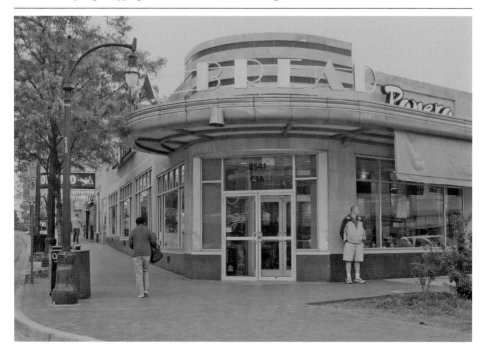

Frank J. Fidler's blacksmith shop was located on the west side of Georgia Avenue south of Fidler Lane (originally Maple Avenue). Fidler (1854–1939) was a second-generation blacksmith and was in the shop helping his father John when Gen. Jubal Early's Confederate army marched by in 1864 on its way to attack Washington. He operated the business from 1880 until old age incapacitated him in 1934. The identities of the individuals in this 1870s photograph are unknown. (SSHS.)

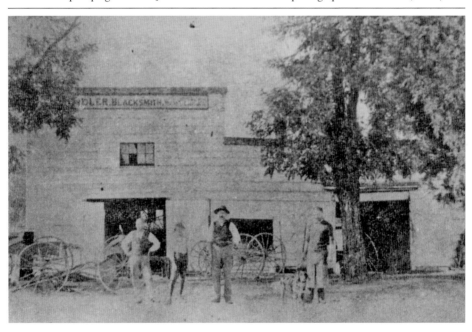

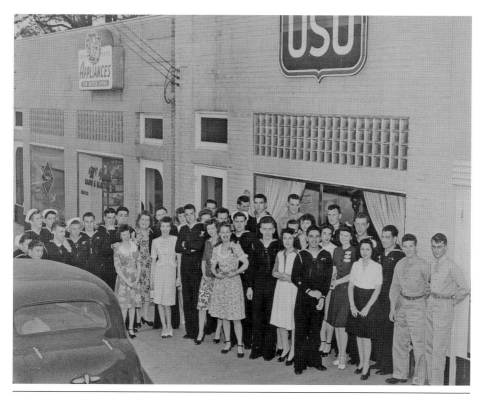

The United Service Organizations Lounge at 8644 Georgia Avenue was in operation from August 30, 1943, to shortly after World War II ended in 1945. The USO continues to support U.S. troops and their families wherever they serve. Del Ankers took this photograph of servicemen and hostesses in 1944. The second woman from the left is Eva R. Keele, the lounge director. The others are unidentified. Twin Tower Apartments, at 1110 Fidler Lane, occupies most of the block today. (BWF.)

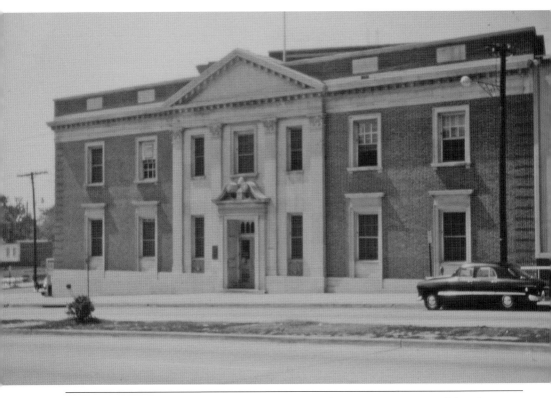

The Chesapeake and Potomac Telephone Company at 8670 Georgia Avenue opened in 1942 and cost $423,000 ($5.6 million in 2010) to construct. Installed was $1,666,800 ($22.2 million in 2010) "of the latest dial type [equipment] that will have a capacity of about 15,000 lines," according to the February 19, 1942, issue of the *Silver Spring Standard*. Telephone service came to Silver Spring in 1889, and there were 11,539 telephones by 1942. As the number of area phone lines grew, so did the floors of the building, with three later additions totaling seven floors. (GCD.)

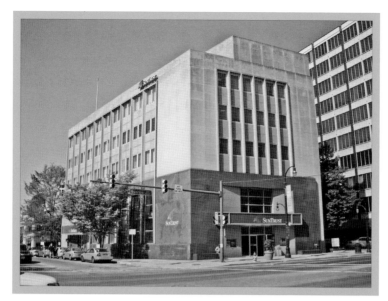

The 1958 Perpetual Building Association structure at 8700 Georgia Avenue is the finest example of postwar International-style architecture in Silver Spring. Designed by Robert O. Scholz and the Bank Building and Equipment Corporation of St. Louis, Missouri, it cost $1.5 million ($11.2 million in 2010). Still occupied by a bank, the structure is wrapped in Carnelian granite to symbolize permanence and protection. The owner plans to raze it to build a 14-story apartment building. This Walter Oates photograph appeared in the March 4, 1961, *Evening Star*. (STAR.)

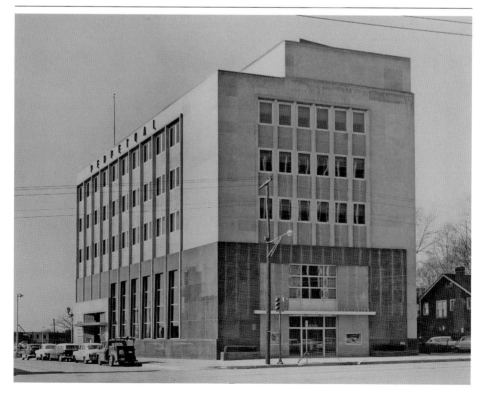

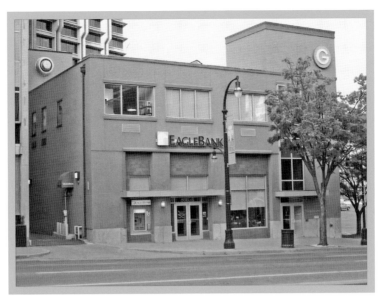

Architects Frank Proctor and Ted Englehardt designed the Bank of Silver Spring, which opened in 1949 at 8701 Georgia Avenue (now 8665). Originally designed with six floors, the cost was $300,000 ($2.7 million in 2010). In 1961, W. W. Chambers purchased the building for conversion into its fifth funeral home, shown here in the 1980s. In 1990, the U.S. District Court of Maryland occupied the building, and in 2006, the building returned to its roots when a branch of Eagle Bank opened. (MCHPC.)

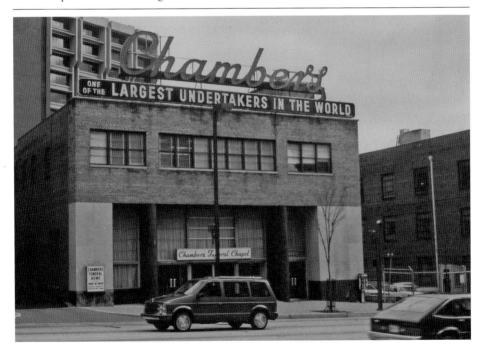

COLESVILLE ROAD

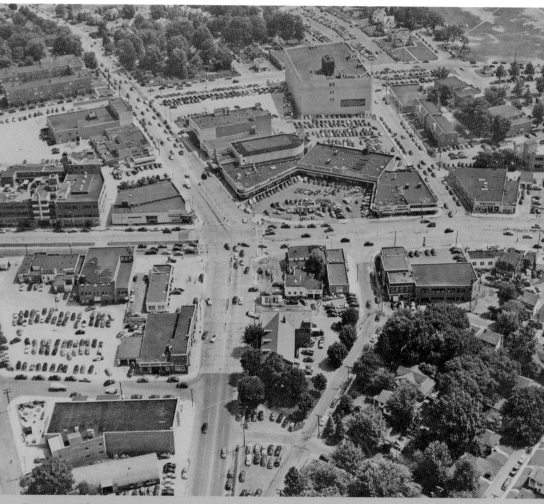

Downtown Silver Spring's other main street is Colesville Road, seen in this 1950 photograph by Gene Abbott. Built in 1864 as the Ashton, Colesville, and Sligo Turnpike, Colesville Road is part of U.S. Route 29. It enters the image at top left between the trees and intersects with Georgia Avenue. Half of the commercial structures shown fronting Colesville have survived. (STAR.)

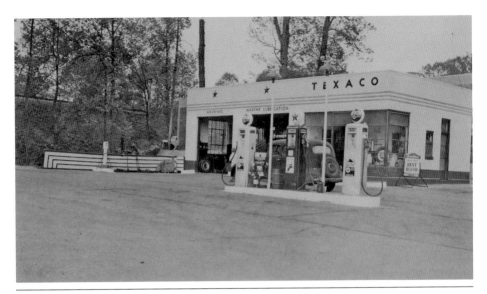

This Texaco service station sat next to the Baltimore and Ohio Railroad tracks on Colesville Road where it intersects with East-West Highway. Photographed in May 1947, by 1973 the building was being shared with National Car Rental. By 1986, the site was occupied by a nine-story, 120,000-square-foot office building with an address of 1335 East-West Highway. The General Services Administration purchased the building in 1987 to house employees of the National Oceanic and Atmospheric Administration. (SSHS.)

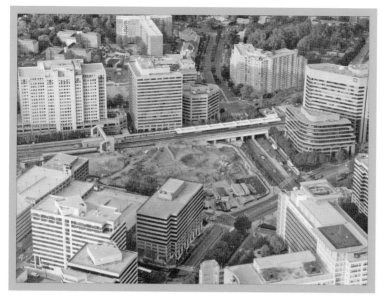

This 1955 aerial view shows Colesville Road going under the Baltimore and Ohio Railroad tracks. Near the bottom center is Reindeer Frozen Custard, surrounded by a parking lot and picnic area. By 1978, this property was replaced by Washington Metro Area Transit Authority Metrobus bays fronting the entrance to Metrorail's Red Line Silver Spring Station. In 2007, construction began on the Paul S. Sarbanes Transit Center, a multimodal transit center to open in 2011. The 2009 aerial photograph is by Evan Glass. (STAR.)

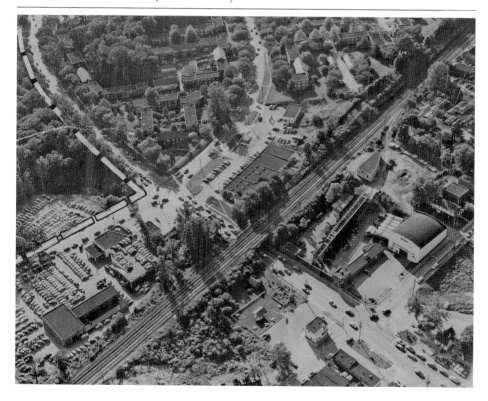

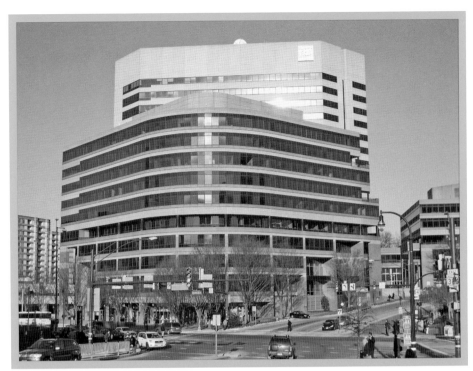

Griffith and Perry, Inc., a coal, fuel, oil, masonry, lumber, and millwork supplier, was located at 8411 Colesville Road, parallel to the Baltimore and Ohio Railroad tracks. A spur line branched off from the B&O, shown elevated behind the building in this 1947 photograph, allowing coal to be delivered. This site is now occupied by three office buildings totaling 756,363 square feet and collectively named Metro Plaza. Located at 8401–8403–8405 Colesville Road, they were constructed in 1986. (SSHS.)

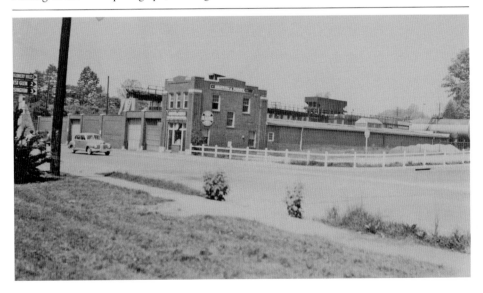

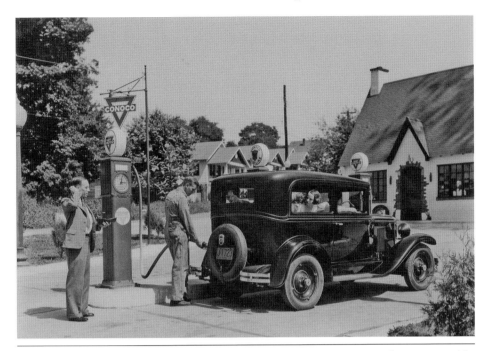

"I wonder if I'll have enough money to pay for this?" Dad might be saying this as he gasses up at the Continental Oil Company (CONOCO) station on Colesville Road. The year on the automobile's license plate is 1932. The background bungalows were located on Maple Avenue (today's Fidler Lane), and their footprints today are occupied by the Portico Apartments. A McDonald's at 8407 Colesville Road, constructed in 1998, occupies the site of the CONOCO. The photograph is by Theodor Horydczak. (LC-THC.)

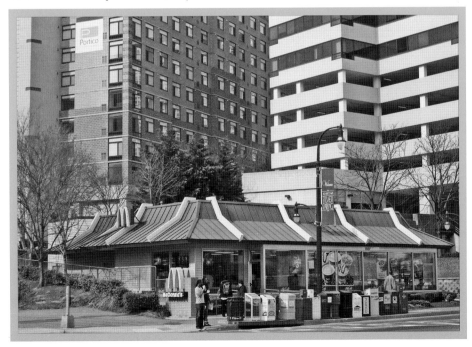

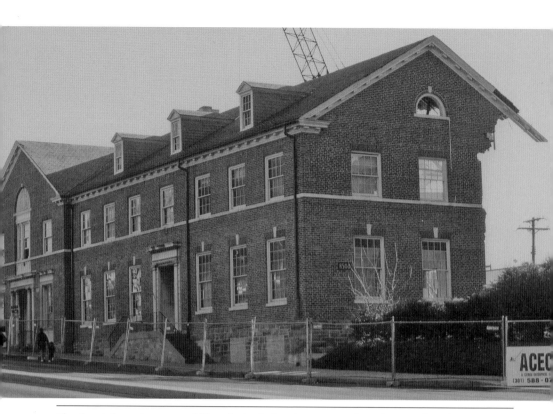

The closest that unincorporated Silver Spring had to possessing a town hall was the Montgomery County Office Building, located at 8500 Colesville Road. Opened in 1935, this $80,000 facility ($1.46 million in 2010) was designed by Laurence P. Johnston and built primarily as the county liquor dispensary and warehouse with Park and Planning offices. The building, including its prominent bas-relief concrete Great Seal of Maryland, was demolished in 1996. Discovery Communications, Inc., opened on the site in 2003. (JAM.)

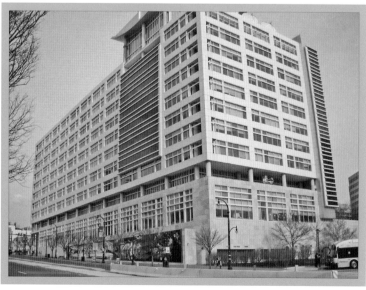

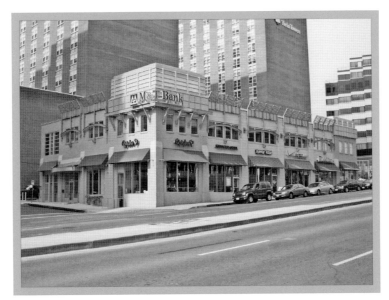

In 1938, Silver Spring architect Joseph J. Schlosser was commissioned by William A. "Buck" Walsh to design the Walsh Motor Company at 8511–8525 Colesville Road, the "New Home of Ford and Lincoln-Zephyr in Silver Spring." Over the decades, a variety of businesses occupied the structure until December 7, 2003, when a two-alarm fire caused $1.5 million in structural and content damage. Six years would pass before renovation work began and with it the erasure of many original architectural elements. (SSHS.)

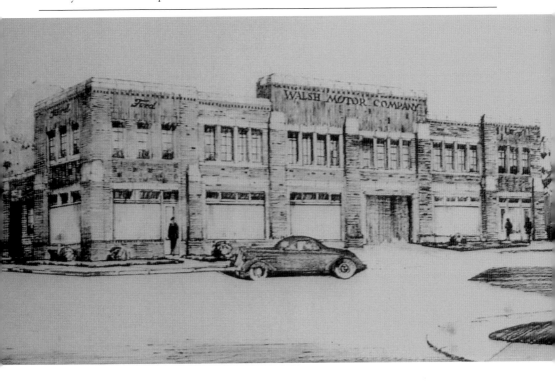

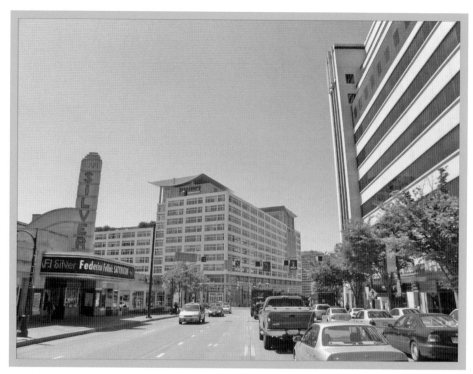

A White Tower hamburger stand occupied the prominent northeast corner of Colesville Road and Georgia Avenue from 1938 to 1946. In 1947, this building at 8600 Colesville Road was relocated to the opposite side of the parking lot and given a new address of 8628. The move was to accommodate construction of Hahn Shoes, opened in 1949. Hahn's was demolished in 1985 for construction of Lee Plaza (right), opened the following year at 8601 Georgia Avenue. (SSHS.)

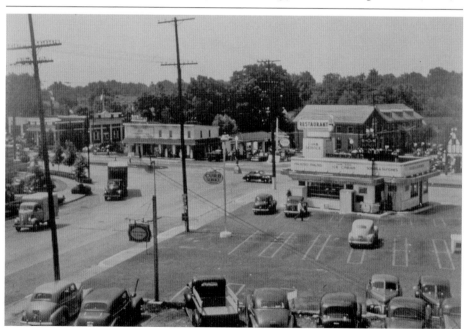

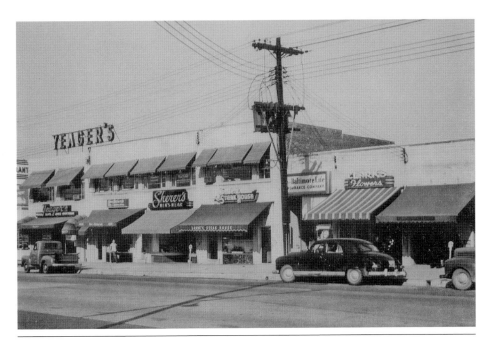

A large neon sign marked (Herbert) Yeager's Ladies Shoppe at 8630 Colesville Road. Opened in 1943, this popular clothing store remained in operation until 1967. Other businesses in this early 1950s photograph were Nan Richard's Town and Country Clothes, (Moses) Sherer's Men's Wear, Louie's (Louis E. Fine) Steak House, Baltimore Life Insurance Company, and (Howard) Clark's Flowers. All of these buildings on the north side of the 8600 block are now part of the Silver Spring CBD Historic District. (SSHS.)

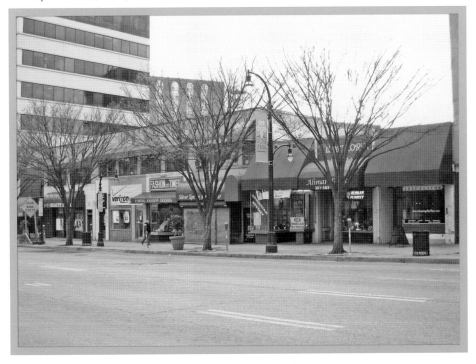

The Silver Theatre, at 8633 Colesville Road, appeared in the 1957 Montgomery Blair High School's *Silverlogue* yearbook. Designed by John Eberson, the theater opened in 1938 and closed in 1984. A two-decade-long preservation battle was waged by the Art Deco Society of Washington to save the structure and the Silver Spring Shopping Center. The original "Silver" marquee had been demolished but was replicated in 2003 when the theater reopened as the East Coast home of the American Film Institute. (SSHS.)

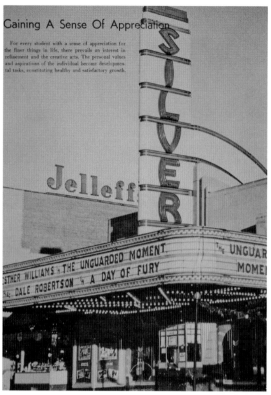

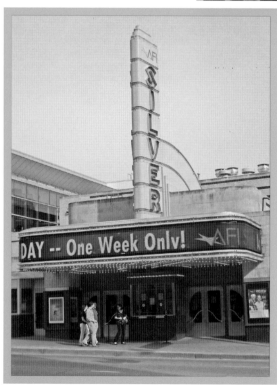

Reindeer Frozen Custard was located at 8651 Colesville Road from 1940 to 1949. The business was co-owned by Thelma B. Pease and her twin sister, Vera B. Emery. Thelma Pease was occasionally helped by her husband, Arthur, and their three sons, Arthur Jr., Robert, and Ronald. The Pease family lived in the house seen just behind the shop. By 1992, the site was occupied by City Place Mall, a 400,000-square-foot enclosed shopping center. (RBP.)

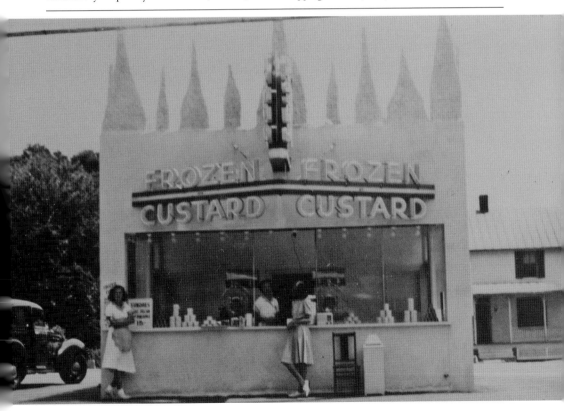

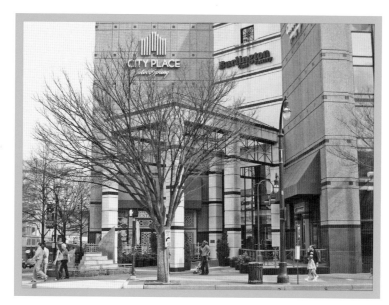

One thousand pigeons were released from the roof of the new Colesville Road addition to the Hecht Company department store when it was dedicated on October 31, 1955. *Evening Star* photographer Francis Routt captured the eager crowd waiting to see the $1.5-million addition ($12.12 million in 2010), which included a bookstore, optical department, and restaurant. In 1992, City Place Mall replaced this structure. Both additions tied into the original 1947 Hecht store, located to the rear. (STAR.)

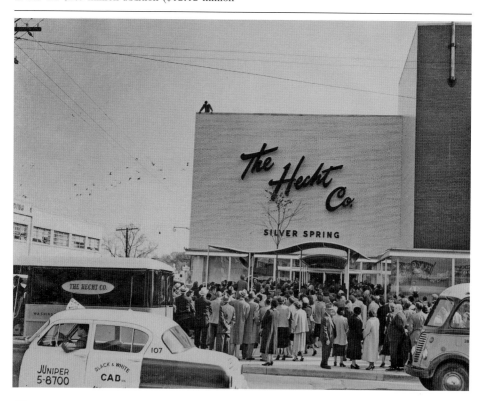

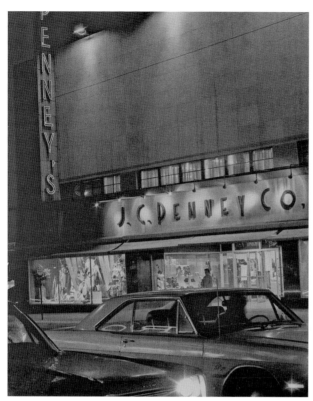

This nighttime view of the J. C. Penney Company, 8656 Colesville Road, was taken in 1971 by Dave Stovall. Opened August 17, 1950, this store location went out of business in 1986. A facet of the Silver Spring CBD Historic District, the limestone facade will be restored (except for the lettering) and incorporated into planned construction for a 28,000-square-foot Fillmore music club scheduled to open in September 2011. (DS.)

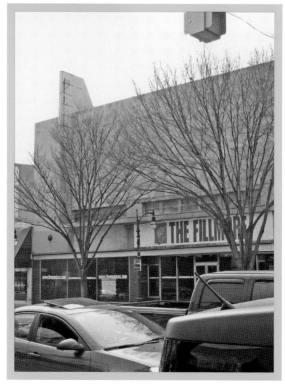

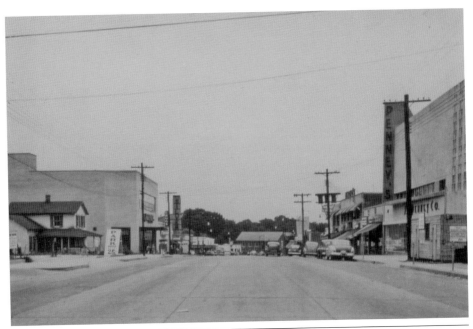

Looking west on Colesville Road, the wood-frame house on the left was one of six in 1931 that occupied this side of the block between Georgia Avenue and Fenton Street. Here lived Jane and Thomas Quilter, who died in the house in 1939 and 1947 respectively. The "Park Here 25¢" sign in front of the house shows that by at least 1950, when J. C. Penney opened across the street, the property was being used for commercial purposes. (SSHS.)

COLESVILLE ROAD

Charles H. Roeder constructed his home at 8727 Colesville Road in 1921–1922. By 1957, with the surrounding properties on the block having been rezoned for commercial use, the house was sold and demolished. In 1962, construction began on the Fire Fountain Inn, an 11-story, 162-room hotel designed by Fon J. Montgomery. It opened a year later under the Sheraton name and in 2001 became part of the Hilton chain. Roeder Road is located behind the hotel. (CFM.)

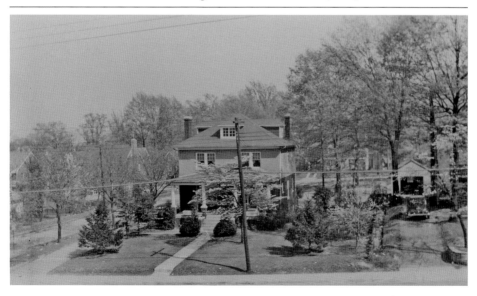

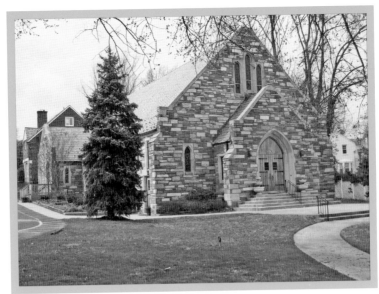

The first service in the Seventh-day Adventist Church of Silver Spring occurred on April 1, 1950. Located at 8900 Colesville Road, the Gothic stone structure was designed by Ronald S. Senseman and cost $125,000 to construct ($1.13 million in 2010). Senseman also designed Silver Spring's endangered First Baptist Church, 8415 Fenton Street (1956); the remodeled Park Silver Hotel (now a Days Inn) at 8040 Thirteenth Street (1956); and the intact Springvale Terrace Retirement Home, 8505 Springvale Road (1963). (STAR.)

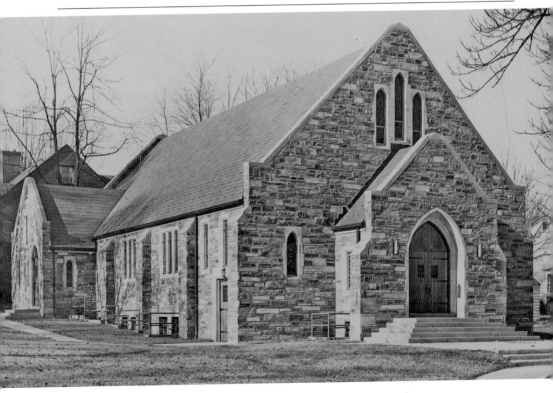

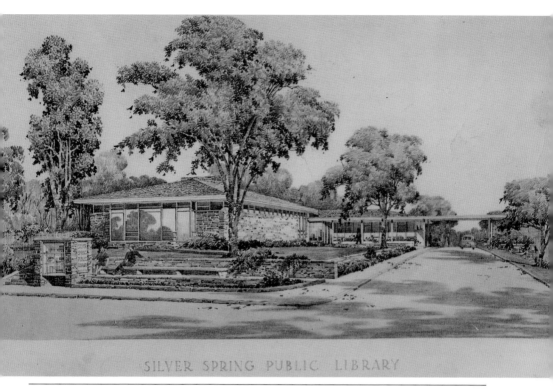

SILVER SPRING PUBLIC LIBRARY

Architect Rhees Burket's original design for the Silver Spring Library, at 8901 Colesville Road, appeared in the February 26, 1955, Washington *Evening Star*. Eliminated from the design was a bus waiting station and outdoor display case. Opened in 1957, the structure cost $280,000 ($2.15 million in 2010). Scheduled for replacement by a new library to be located on the southwest corner on Wayne Avenue and Fenton Street, the future of this important example of mid-century civic architecture remains unknown. (STAR.)

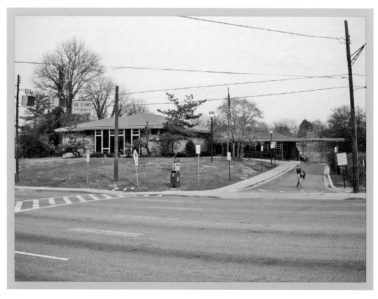

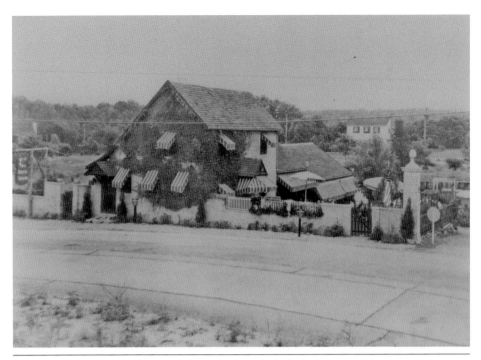

Mrs. K's Toll House at 9201 Colesville Road has the unique distinction of being the oldest operating restaurant in Silver Spring. Opened by Harvey and Blanche Kreuzburg on April 1, 1930, the structure began life on a much smaller scale as Toll Gate No. 1 on the Ashton, Colesville, and Sligo Turnpike (closed around 1913). It took on its current incarnation in 1923 when remodeled by architect Ward Brown to serve as the entrance to the Seven Oaks subdivision. (SSHS.)

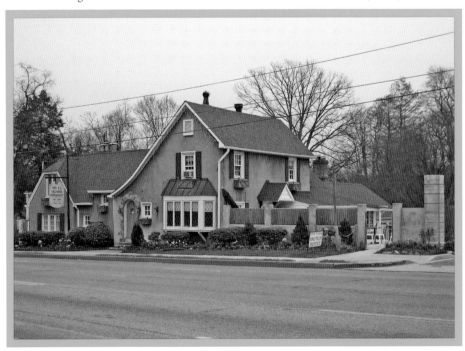

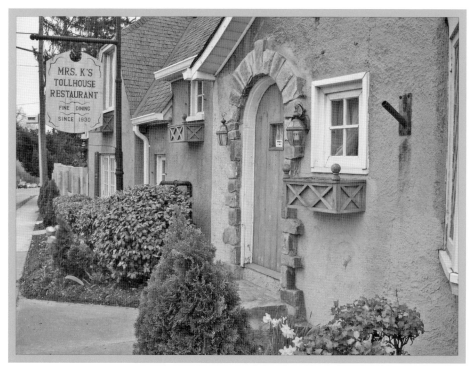

Howard S. Fisk took this photograph of the Ashton, Colesville, and Sligo Turnpike's Toll Gate No. 1 on March 31, 1912. The structure closed in 1910 with the death of its last toll keeper, Henry Charles Ulrich (born 1849). The board-and-batten structure was incorporated into expanded construction in 1923, later becoming Mrs. K's Toll House at 9201 Colesville Road. The wood-shingled canopy can be seen facing Colesville Road in the 1930 photograph on the previous page. (SSHS.)

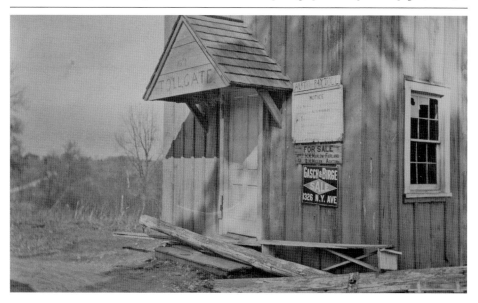

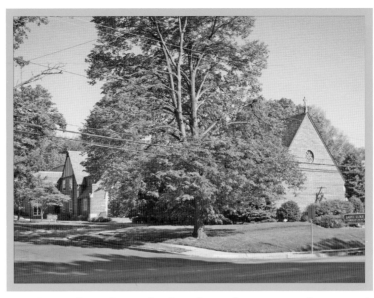

The sanctuary of St. Luke Lutheran Church, located at 9100 Colesville Road, was dedicated on April 7, 1946. The brick structure was designed by Philadelphia architect Charles A. Scheuringer and cost $77,576 ($955,000 in 2010). Scheuringer also designed the National Lutheran Home for the Aged (1947) in Washington, D.C, now the Washington Center for Aging Services, located at 2601 Eighteenth Street, NE. Paul Schmick took this 1948 photograph. Note how tall the elm tree grew in 62 years! (STAR.)

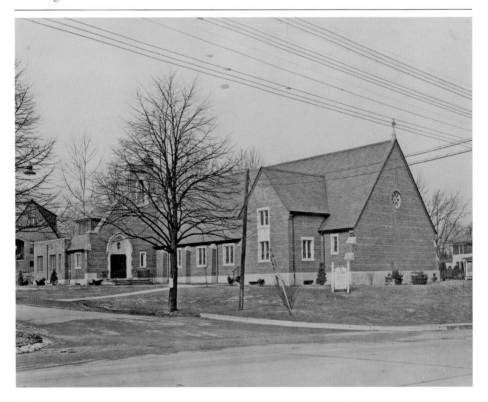

CHAPTER 3

EAST-WEST HIGHWAY
AND EASTERN AVENUE

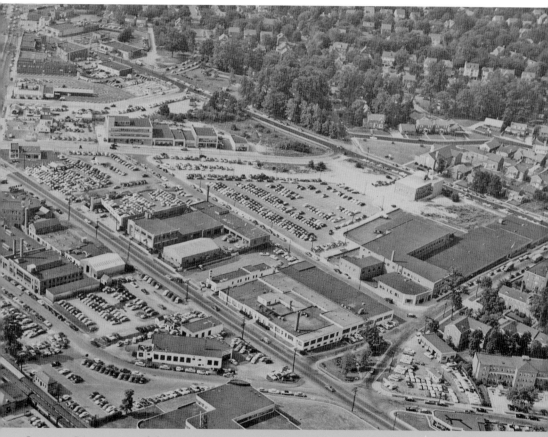

Starting at Georgia Avenue (left), segments of East-West Highway (Maryland Route 410, bottom) and Eastern Avenue (border between Maryland and Washington, D.C, top) parallel one another for half a mile. This 1955 *Evening Star* photograph by Francis Routt shows the area encompassing a mixture of light industry (bottling/printing plants, automobile dealers, and research and development companies) and apartments. (STAR.)

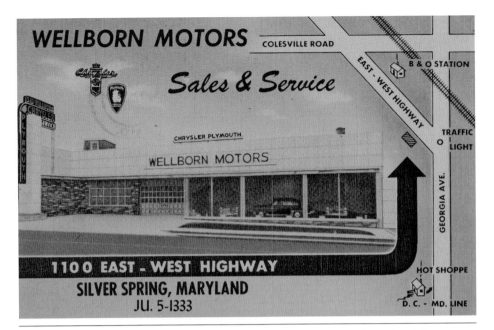

Originally located at 8000 Georgia Avenue, Sid Wellborn opened his new one-story showroom for Chrysler and Plymouth automobiles at 1100 East-West Highway in 1949. Touted as "Conveniently located at the 'Crossroads' of Suburban Washington and Silver Spring," this 1953 postcard was rubber-stamped by salesman Jack Hurd with the message, "For a good deal on an automobile." Remodeled beyond recognition, the structure is today home of the Iglesia de Dios Pentecostal, "La Nueva Jerusalen." (WP.)

This is the earliest known photograph taken of the famous spring after which Silver Spring was named. Photographed in 1865 by Capt. Fred C. Low, Company B, 1st Maine Heavy Artillery, this image is the right half of a stereo-view card. When viewed with a stereoscope, the image appears in three dimensions. In 1955, the topography of the spring site was heavily altered for creation of Acorn Park. The spring grotto opening and stone surround remain intact. (SSHS.)

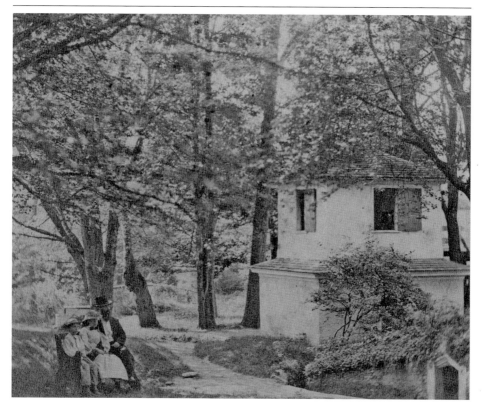

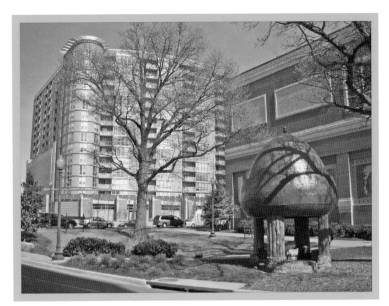

Overlooking the spring site is the Acorn Gazebo, constructed in the 1850s by Washington, D.C., builder Benjamin C. King at the request of Francis Preston Blair. Calvert Motors, who claimed to be the "World's Largest DeSoto dealer in Silver Spring," appears at 1141 East-West Highway in this early 1950s photograph by Don Fugitt. Occupying a portion of the dealership site today is the Veridian Apartments, opened in 2008. Partially visible behind the gazebo is a series of murals completed in 1995 by Mame Cohalan. (SSHS.)

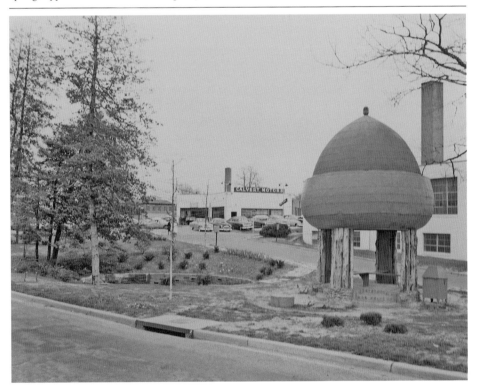

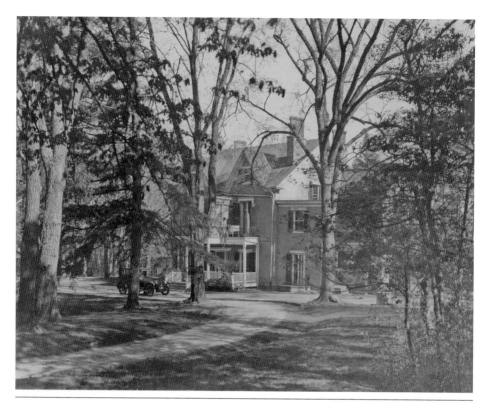

This bucolic 1920s view is of the south elevation of Silver Spring founder Francis Preston Blair's country estate, Silver Spring. Constructed between 1842 and 1845, the mansion contained 20 rooms, four baths, nine fireplaces, two kitchens, and a wine cellar. It was razed in 1954 for construction of an annex to the Montgomery Blair Station Post Office. This structure was in turn razed in 2003 for construction of the 8045 Kennett Street Condominiums. (HSWDC.)

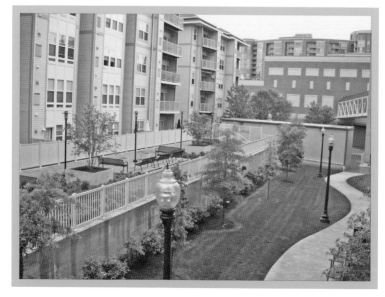

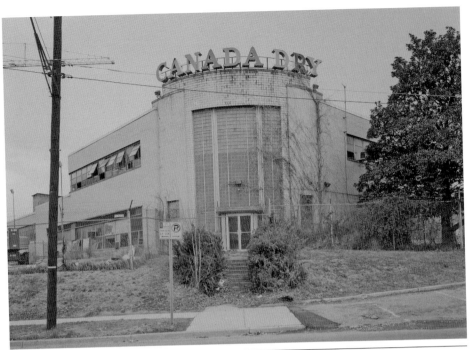

A reproduction of the neon "tiara" Canada Dry sign over the main entrance was included as part of the exterior restoration of the Canada Dry Bottling Plant. The interior of the two-story vestibule features the restored curving cantilevered staircase and terrazzo flooring with circular "carbonation bubbles" design. Chairs on the public plaza were designed by Denver, Colorado, artist Carolyn Braaksma and emulate the prominent curved facade of the building. Jet Lowe took the "then" photograph in 2003. (LC-HAER.)

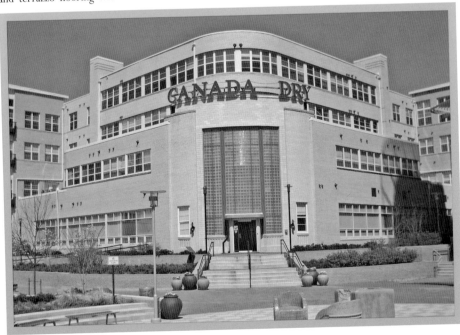

THE EAST-WEST HIGHWAY AND EASTERN AVENUE

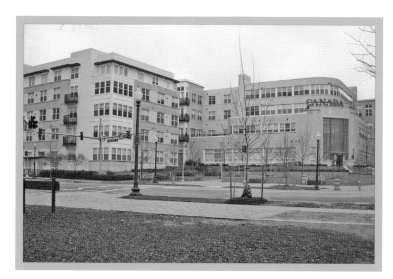

Designed in 1946 by New York City architect Walter Monroe Cory, whose motto was "Factories CAN Be Beautiful," the Canada Dry Bottling Plant at 1201 East-West Highway is the finest example of streamline moderne architecture in Montgomery County. The Silver Spring Historical Society advocated for the preservation and adaptation of the two-story administration office portion of the plant, closed in 1999, for use as the Silverton Condominium, opened in 2005. Judy Reardon took the "then" photograph in 2000. (SSHS.)

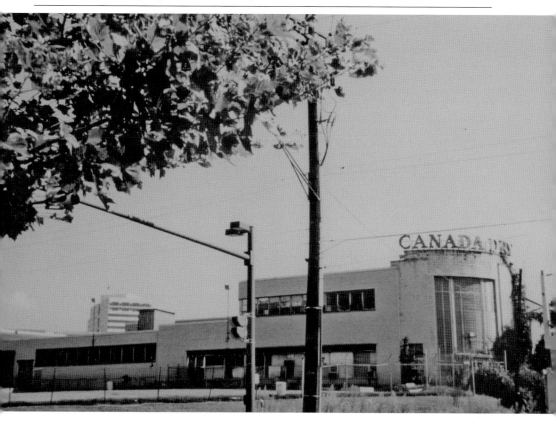

Originally opened in 1947 as Montgomery-Stubbs Motors, Inc., a Lincoln-Mercury dealership, this building at 1200 East-West Highway became a Volkswagen dealership by the late 1950s. Operated as Silver Spring Auto City, Inc., it remained in operation until the early 1990s, when Judy Reardon took this photograph. In 2009, construction began on this site of 1200 East West apartments, trumpeting "Experience Metro Urban Living at Its Best." (SSHS.)

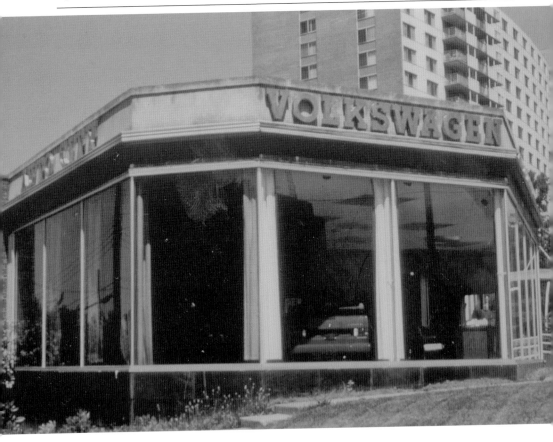

THE EAST-WEST HIGHWAY AND EASTERN AVENUE

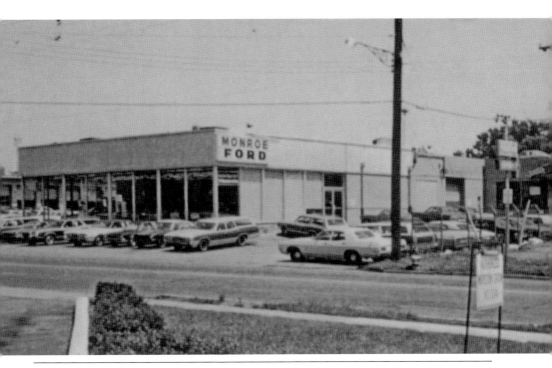

In 1947, John A. Sterrett opened Sterrett Motor Service, Inc., a Ford dealership, at 1237 East-West Highway. In 1949, the dealership was purchased by Harry Monroe Jr., whose company motto for the next 40 years was "Home of the Monroe Doctrine 'Finest Ford Service.'" This *c.* 1972 postcard shows the large showroom added to the front of the original building. In 2003, construction began on this site of the Bennington at Silver Spring Apartments, 1215 East-West Highway. (GL.)

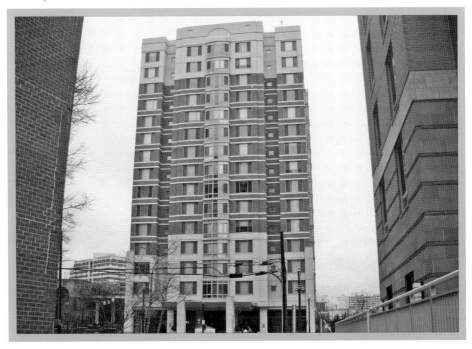

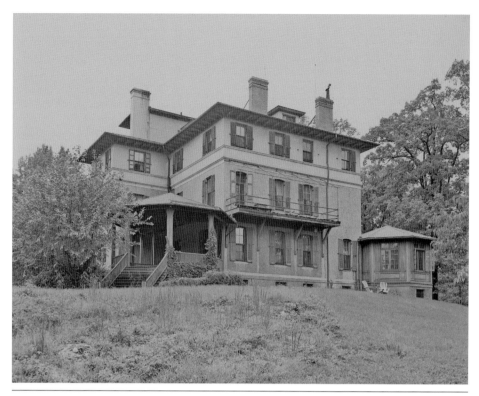

U.S. postmaster general Montgomery Blair's Falkland mansion occupied a tree-covered hill bordered by today's East-West Highway, Colesville Road, and Eastern Avenue. His father Francis Preston Blair's estate, Silver Spring, was located to the southeast. Falkland was rebuilt after it was destroyed during the Civil War on July 12, 1864. By the early 1950s, the mansion was being utilized as a boardinghouse when photographed by Don Fugitt. The Blair Shops parking lot occupies the site of the hill and mansion. (SSHS.)

THE EAST-WEST HIGHWAY AND EASTERN AVENUE

On September 7, 1958, the Silver Spring Volunteer Fire Department No. 1 performed a "controlled burn" of Falkland mansion at the request of the Blair Management Corporation, owned by descendants of U.S. postmaster general Montgomery Blair. Additionally, one other house was destroyed, all of the estate's mature trees were cut down, and the hill was leveled to make way for commercial development. Ward Etheridge Boote Sr. took this view of the mansion in flames from East-West Highway. (GS.)

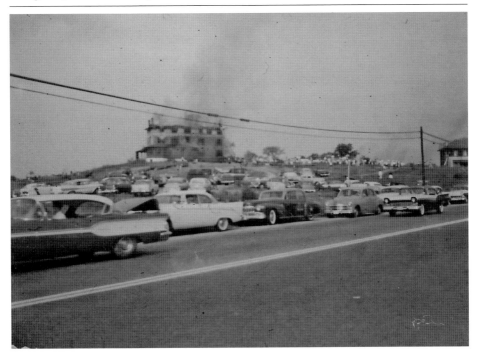

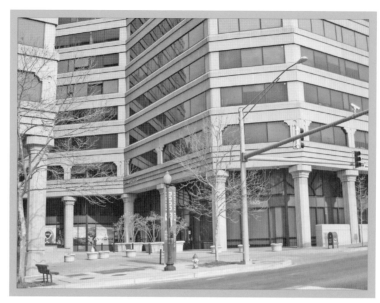

Frank W. Williams opened his Chevrolet automobile dealership in 1948 at 1339 East-West Highway. While the building was under construction in 1947, a vertical neon Chevrolet sign was on display. In 1956, the dealership was taken over by Graham Loving, whose advertising jingle was, "The prettiest thing in Silver Spring is Loving Chevrolet." By 1986, the site was occupied by the National Oceanic and Atmospheric Administration, a nine-story, 120,000-square-foot office building at 1335 East-West Highway. (SSHS.)

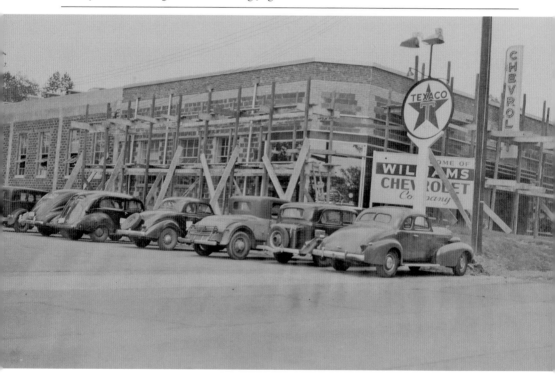

Dedicated in 1936, architect Louis Justement's New Deal–era Falkland Apartments was the first apartment complex in Maryland to receive mortgage insurance from the Federal Housing Administration. Judy Reardon took this photograph in 1987 of one of the 34 brick townhouses with screened porches and private yards located in the Draper Triangle portion of the complex shortly before demolition. On this site stands the 17-story, 400-unit Lenox Park Apartments, opened in 1992 at 1400 East-West Highway. (SSHS.)

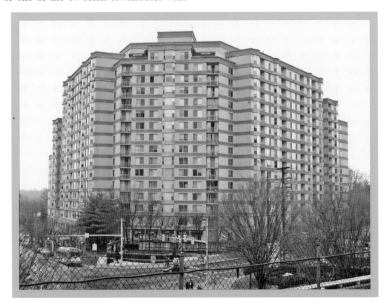

The 1792 north cornerstone is the oldest man-made object in Silver Spring and among the oldest federal monuments in Washington, D.C. Located in the 1800 block of East-West Highway, the stone is one of 40 surveyed by Andrew Ellicott and Benjamin Banneker from 1791 to 1792 to mark the boundaries of the original District of Columbia. Photographed around 1916 by Fred E. Woodward, water runoff over 94 years has deposited soil that has left only 10 inches of the stone visible (it was originally 2 feet high). (WASH.)

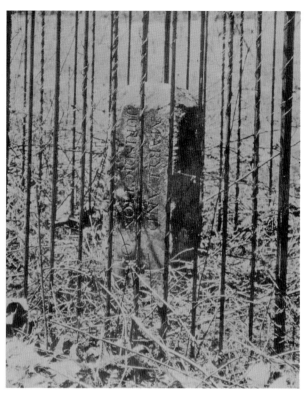

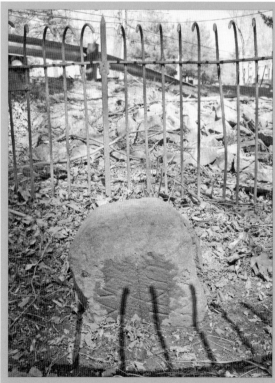

THE EAST-WEST HIGHWAY AND EASTERN AVENUE

This 1930s postcard photograph shows the north cornerstone in relation to East-West Highway. Connecting Bethesda to Silver Spring, the highway opened in 1929. The circular wrought-iron cage was placed around the stone by the Maryland Chapter of the Daughters of the American Revolution in 1916. The small stream to the right of the cage is water runoff from the highway that has slowly been burying the cornerstone. (WP.)

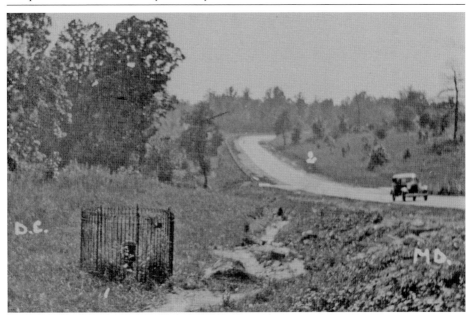

Northeast No. 1 boundary stone was one of 40 stone markers whose locations were surveyed from 1791 to 1792 by Andrew Ellicott and African American Benjamin Banneker to mark the borders of the original District of Columbia. This stone, installed in 1792, was photographed on October 8, 1917. It disappeared in 1952, and on January 12, 1961, a bronze sidewalk plaque (lower right) was dedicated at 7847 Eastern Avenue by the Mary Washington Chapter of the Daughters of the American Revolution. (WASH.)

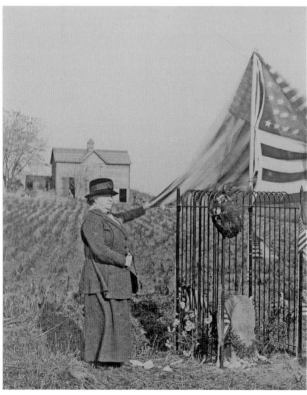

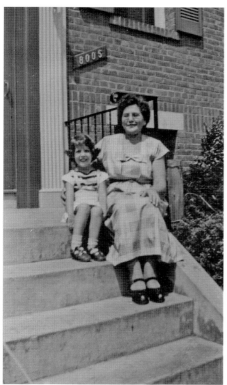

In 1950, four-year-old Anne P. Solotar posed with her visiting grandmother Ida Boxer on the entrance steps to her family's home at Rock Creek Springs Apartments, 8005 Eastern Drive. Anne lived in apartment 201 from 1948 to 1960 with her parents Edward M. and Sophie Solotar. Edward Solotar became a renowned Washington, D.C., area swim coach. Sixty years later, Anne posed on the same steps (she no longer lives there) with her daughter, Sophie Siegel. (APS.)

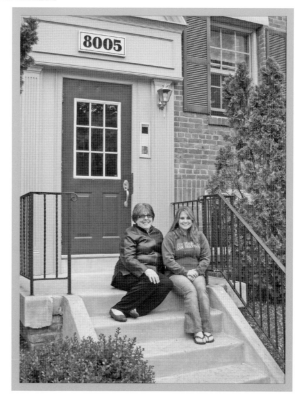

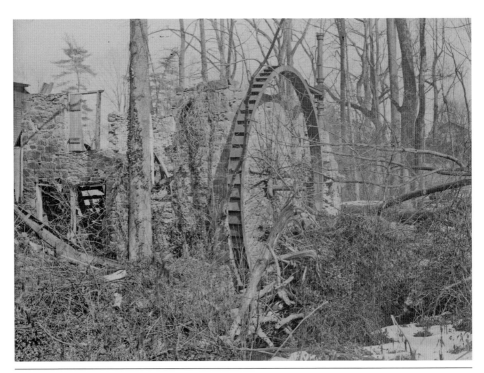

This photograph is the only known image of Francis Preston Blair's Old Blair Mill, taken around 1900. The mill stood at the intersection of today's Blair Mill Road and Eastern Drive. Water from the Silver Spring, located a tenth of a mile to the east, was diverted through a millrace to turn the water wheel. By the late 1940s, the mill had been nearly reduced to rubble, and by 1963, it was replaced by the Blair Plaza Apartments at 1401 Blair Mill Road. (LC-NPC.)

THE EAST-WEST HIGHWAY AND EASTERN AVENUE

SILVER SPRING PARK AND FENTON VILLAGE

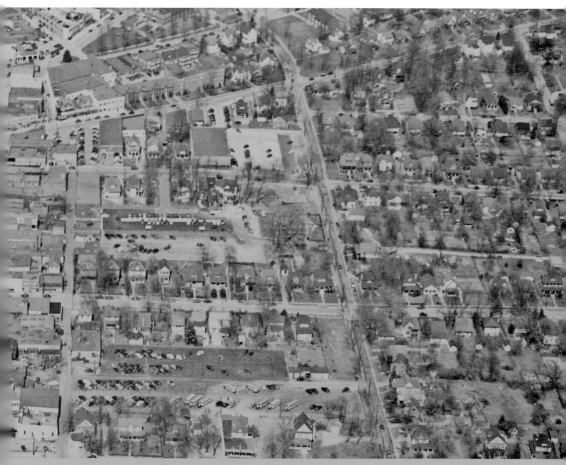

Silver Spring Park, a subdivision located east of Georgia Avenue, was platted in 1905. Over the decades, this name was replaced by the generic East Silver Spring, which extends all the way to the Capital Beltway and the Montgomery–Prince George's County border. In 1997, the Montgomery County government designated the area between Georgia Avenue and Fenton Street as Fenton Village. This 1952 aerial view by Don Fugitt shows many of the long-razed houses that originally were located here. (SSHS.)

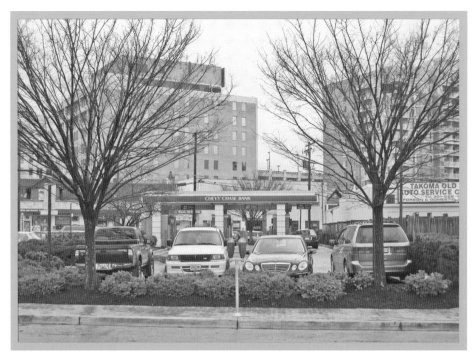

This building at 951 Thayer Avenue originally housed the Washington Schools of Ice Skating, which opened in October 1957. Later named Silver Spring Ice Skating, the rink was managed by former Ice Capades performer Walter Chapman. On November 26, 1969, Roth's Silver Spring East Theatre opened in the structure, remaining in operation until around 1988. The Charles Bronson comedy *From Noon to Three* played October 20–26, 1976. A Chevy Chase Bank drive-up ATM occupies the building's footprint today. (RKH.)

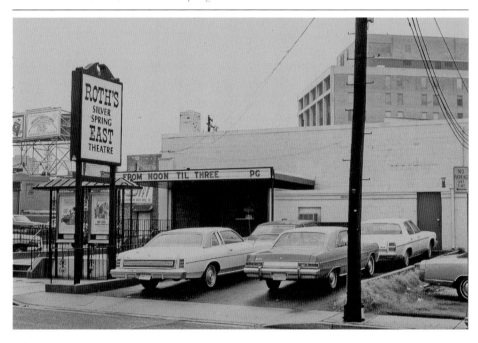

SILVER SPRING PARK AND FENTON VILLAGE

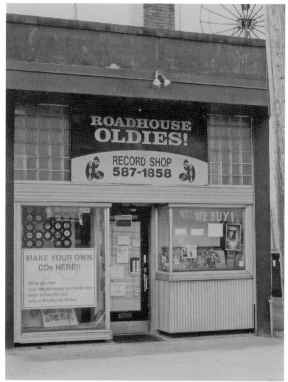

The facade of 958 Thayer Avenue was a rare example of a Pittco Store Front, manufactured in 1946 by the Pittsburgh Plate Glass Company and consisting of two display windows encased with intricately cut and installed aluminum trim, molding, sash, and fluted panels topped by opaque glass blocks. The store was the home of Roadhouse Oldies from 1974 to 2008. The sign and storefront (razed in 2009) were donated to SSHS, which hopes to recreate it in a new location. (SSHS.)

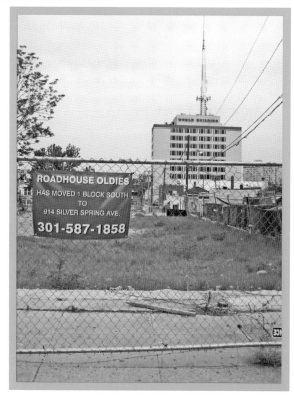

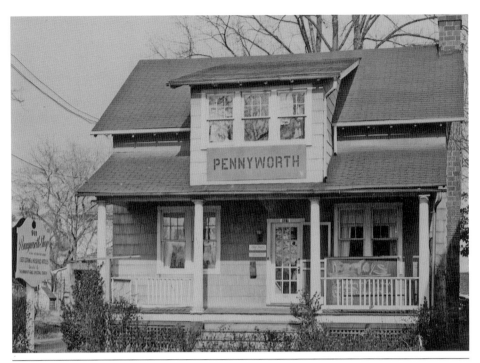

Pennyworth Shop, a thrift store operated by members of Silver Spring's Grace Episcopal Church, occupied this bungalow at 911 Thayer Avenue between 1953 and 1956. Half a century later, this popular shop is located one block north at 955 Bonifant Street and continues to sell donated clothing and household goods at affordable prices. The house was demolished in the 1980s, and a portion of a Safeway grocery store parking lot occupies the footprint of the house. (GEC.)

This November 1951 publicity photograph was taken by Don Fugitt of Angelique's Parfum Carriage, parked next to today's 912 Thayer Avenue. Customers who purchased $5 or more of the perfume from Jelleff's, "specialists in womens', misses', and junior apparel and accessories" at 8635 Colesville Road, could have the product delivered to their "Very Special Person" in this c. 1908 Glide touring car. The Glide was an American automobile manufactured by the Bartholomew Company in Peoria Heights, Illinois, from 1902 to 1920. (SSHS.)

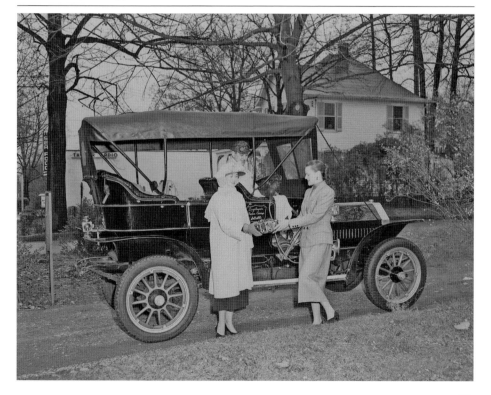

Wrenn's Nest was the moniker given to 902 Thayer Avenue in 1919 by owners John L. and Nora E. Wrenn. The 1920 U.S. Census indicates that John Wrenn was the electrician in charge of the U.S. Government Printing Office. Also living in the house were the couple's son and daughter-in-law, four boarders, and a 16-year-old African American servant named Alberta Hunt. The house, built in 1909 for William B. Newman, was razed in the early 1960s. (RKN.)

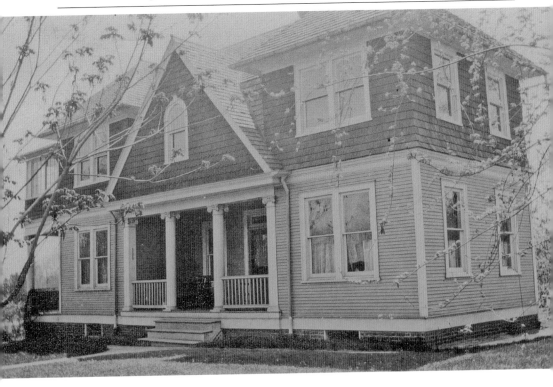

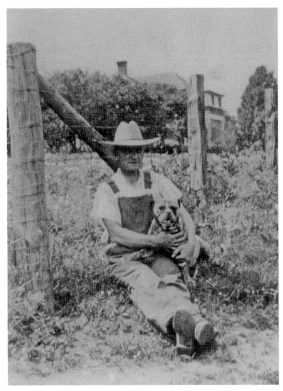

William Boroughs Newman (1866–1937) posed in August 1920 with his dog on the Fenton Street side of his former home, visible just behind the trees at 902 Thayer Avenue. Newman worked for the federal government as an attorney from 1893 to 1931. Attorney Stevan Lieberman and his dog, Nesta, who live one block away on Silver Spring Avenue, pose in the same spot 90 years later. (RKN.)

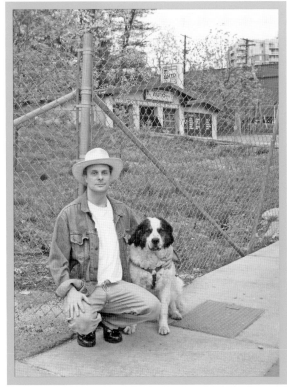

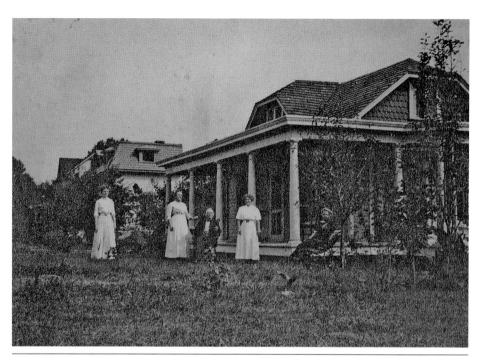

On July 28, 1912, John Benjamin Faulconer (1844–1925) posed in front of his house at 736 Thayer Avenue with, from left to right, daughter Eva Priscella (Faulconer) Gehrman, wife Mary Margaret (Johnson) Faulconer, daughter Emilie Norton (Faulconer) Perry, and possibly Mary's sister Elizabeth N. (Johnson) Magee. Faulconer was a private during the Civil War, serving in the 6th and 9th Regiments, Virginia Cavalry. The house was severely damaged by fire in 1967 and torn down. The lot remains vacant. (DD.)

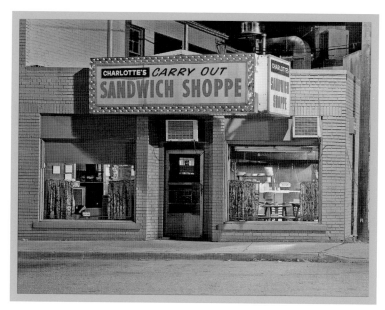

Dave Stovall captured this nighttime view of Charlotte Terner's Sandwich Shoppe at 963 Bonifant Street in 1971. Since 1996, this 1928 structure has been occupied by Kefa Café, owned and operated by, from left right, sisters Lene and Abeba Tsegaye. This organic coffee, tea, and sandwich business has become a beloved neighborhood institution, offering not only drink and food but art displayed in the connected "Space 7:10" gallery, named for the clock on the wall perpetually stopped at 7:10. (DS.)

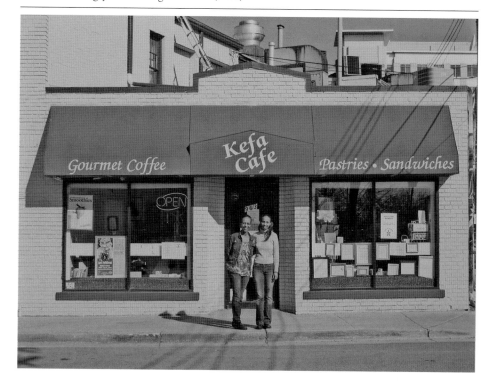

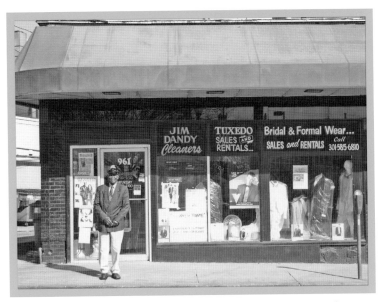

In 1946, Samuel L. Myers started working in the dry-cleaning business in Washington, D.C. In 1972, he opened Jim Dandy Cleaners at 935 Pershing Drive, and he remained there until 1988, when he relocated to 961 Bonifant Street after the building he occupied was razed. Every Monday through Saturday, 95-year-old Reverend Myers can be found at his shop. His is the oldest African American–owned and –operated business in downtown Silver Spring. (MCHPC.)

This *c.* 1910 American foursquare house first avoided the wrecker's ball when it was relocated from the corner of Georgia and Thayer Avenue to 900 Bonifant Street around 1923. In 2003, the house was endangered again by planned construction of a condominium. At the urging of SSHS, the developer offered to give the house for free to anyone who would move it. No takers came forward. Loft 24, constructed in 2006, sits on a portion of the site today. (JAM.)

Since 1956, the First Baptist Church of Silver Spring has graced the corner of Wayne Avenue and Fenton Street. Designed by Ronald S. Senseman, the structure cost $400,000 to build ($3.2 million in 2010). This landmark structure, photographed in 1957 by Jack Horan of the *Evening Star*, stands next to the church's original 1925 parsonage. The church has proposed razing both structures. Paint was applied to the photograph to hide the telephone wires in front of the church. (STAR.)

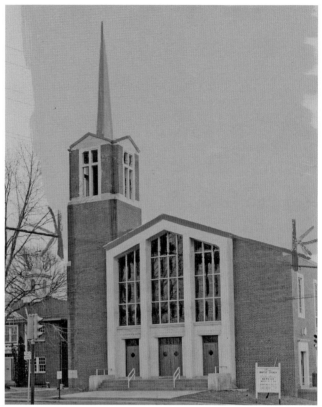

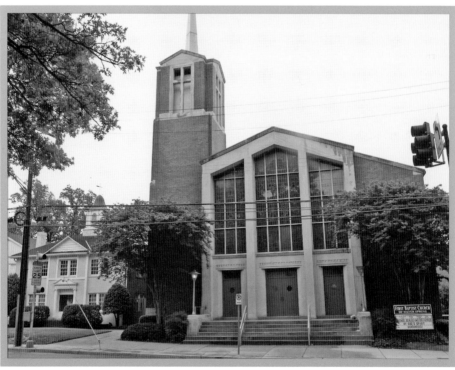

INDEX

Discover Thousands of Local History Books
Featuring Millions of Vintage Images

Arcadia Publishing, the leading local history publisher in the United States, is committed to making history accessible and meaningful through publishing books that celebrate and preserve the heritage of America's people and places.

Find more books like this at
www.arcadiapublishing.com

Search for your hometown history, your old stomping grounds, and even your favorite sports team.

Consistent with our mission to preserve history on a local level, this book was printed in South Carolina on American-made paper and manufactured entirely in the United States. Products carrying the accredited Forest Stewardship Council (FSC) label are printed on 100 percent FSC-certified paper.

MADE IN THE USA